Narrative Picture Scrolls

EDITORIAL SUPERVISION
FOR THE SERIES

Tokyo National Museum
Kyoto National Museum
Nara National Museum
with the cooperation of the
Agency for Cultural Affairs
of the Japanese Government

FOR THE ENGLISH VERSIONS

Supervising Editor
John M. Rosenfield
Department of Fine Arts, Harvard University
General Editor
Louise Allison Cort
Fogg Art Museum, Harvard University

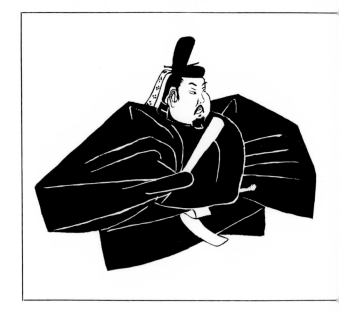

NARRATIVE PICTURE SCROLLS

by Hideo Okudaira

translation adapted with an introduction by Elizabeth ten Grotenhuis

New York · WEATHERHILL/SHIBUNDO · *Tokyo*

This book appeared originally in Japanese under the title Emakimono *(Narrative Picture Scrolls), as Volume 2 in the series* Nihon no Bijutsu *(Arts of Japan), published by Shibundō, Tokyo, 1966.*

The English text is based directly on the Japanese original, though some small adaptations have been made in the interest of greater clarity for the Western reader. Modern Japanese names are given in Western style (surname last), while premodern names follow the Japanese style (surname first).

For a list of volumes in the series, see the end of the book.

First edition, 1973

Published jointly by John Weatherhill, Inc., 149 Madison Avenue, New York, N.Y. 10016, with editorial offices at 7–6–13 Roppongi, Minato-ku, Tokyo; and Shibundō, 27 Haraikata-machi, Shinjuku-ku, Tokyo. Copyright © 1966, 1973 by Shibundō; all rights reserved. Printed in Japan.

Library of Congress Cataloging in Publication Data: Grotenhuis, Elizabeth ten./Narrative picture scrolls./(Arts of Japan, 5)/Adapted from Emakimono./Bibliography: p. /1. Scrolls, Japanese./2. Painting, Japanese./3. Japan—Social life and customs—Pictoral works. I. Okudaira, Hideo, 1905– Emakimono. II. Title./ND1053.G76 1974/759.952/73–9619/ISBN 0–8348–2710–7 ISBN 0–8348–2711–5 (pbk.)

Contents

Adapter's Preface

THANKS TO THE scrupulous scholarship of Mrs. Yasuko Horioka, who did the original translation of the Japanese text, it has been possible to develop a book in English that retains the inherent interest and charm of Mr. Okudaira's work. Because the book was intended for Japanese readers and assumed a great deal of prior knowledge about Japan, I have edited, rewritten, and reorganized considerably. Much new explanatory information has been incorporated: within the chapter entitled "Historical Development," The Heritage of China, The Buddhist Narrative Tradition, and The Legacy of the Emaki and Yamato-e are entirely new sections. In adding this information, my aim has been to complement Mr. Okudaira's work and to enlarge on some of the themes he suggests. The chapter entitled "The Emaki as an Art Form" was culled from various shorter chapters in the original Japanese work, for it seemed wisest to reorganize and arrange in a more logical manner the array of material presumably unfamiliar to the general Western reader.

The book has a useful format: Not only are the history and artistic characteristics of illustrated handscrolls discussed, but there is also an extensive section entitled "Selected Individual Emaki" that offers synopses of the plots of forty-four major *emaki* as well as other pertinent information about them. It is suggested that the reader use these notes as he encounters the various *emaki* mentioned only briefly in the text as examples or illustrations.

The great appeal of these narrative picture scrolls lies not only in the skill and imagination with which the illustrations were composed and painted, but also in the panorama of Japanese life and culture they present. It is this combination that Mr. Okudaira has endeavored to explore and develop so as to deepen our understanding and appreciation of this unique art form and that all of us who have worked on the English version of the book have sought to preserve.

E. ten G.

Introduction: The Emaki and Yamato-e

THE EMAKI or "picture scroll" is a unique and dramatic form of art. Holding an *emaki* scroll in his hands, the viewer gradually unrolls a pageant of interwoven scenes and text as he becomes immersed in the unfolding story. This intimate handscroll format, so well suited to narrative, captured the imaginations of Japanese artists and patrons for centuries. Hundreds of *emaki,* dating mainly from between the twelfth and sixteenth centuries, exist today to bear witness to the importance of this art form in medieval Japan. The form lent itself to every sort of story, from solemn religious accounts to romantic intrigues to rollicking adventures and homely folk tales. It was the major vehicle for the rich and lyrical style of painting known as *yamato-e.*

The Japanese began to make *emaki* under Chinese influence, but the picture scroll in Japan developed into a more dynamic art form than its Chinese counterpart. Although Japanese artists were not indifferent to the portrayal of landscape and nature that was so popular in China, the subject of *emaki* art was generally man; its themes, the way man lives and interacts with his fellow man. The greater part of *emaki* art deals with the tragic and humorous aspects of the human condition and depicts stories and narratives in which the natural and the supernatural are intermingled. Scroll paintings may be roughly divided into two types according to content—religious and secular—but many contain elements of both types. Most *emaki* in the religious category were inspired by Buddhist themes, although some are related to Shintoism. Such scrolls, many of which were made during the social upheavals of the late Heian and early Kamakura periods (897–1249), often reflect the religious pessimism of the day; they were in part produced to express and to heighten the viewer's longing for escape into paradise by exposing the horrors of the reincarnation cycle (the *Gaki Zōshi* [Scroll of Hungry Ghosts], the *Jigoku Zōshi* [Scroll of Hell], and the *Yamai no Sōshi* [Scroll of Diseases and Deformities]). There were also religious scroll paintings depicting the legendary origins of shrines and temples and the virtues of their principal deities; for example, the *Shigi-san Engi* (Legends of Shigi-san Temple), as well as pictorial biographies of exemplary priests or founders of sects, such as the *Hōnen Shōnin Eden* (Biography of the Monk Hōnen).

Scrolls in the secular category were created to serve aesthetic and narrative purposes and were often painted to illustrate literary works, narrative accounts, folk tales, war stories, *waka* poetry, and documentary records. Most of the literary *emaki* are based on the romantic literature of the Heian (794–1185) and Kamakura (1185–

1336) periods and portray the elegant lives of the court aristocracy; one example is the well-known *Genji Monogatari Emaki* (The Tale of Genji). The narrative accounts, mostly executed during the Kamakura period, deal with supernatural occurrences, bizarre tales, adventure stories, or humorous events. An outstanding example is the *Ban Dainagon Ekotoba* (Story of the Courtier Ban Dainagon). Folk-tale scroll paintings *(otogi zōshi emaki),* based on stories written mostly during the Muromachi period (1336–1568), were also a popular type of *emaki.* The *Fukutomi Zōshi* (Story of Fukutomi) and the *Tsuchigumo Zōshi* (Story of Monstrous Spiders, Plate 39) are examples. Although literary sources indicate that a large number of scrolls dealing with military history was produced, only a few, such as the *Heiji Monogatari Emaki* (The Tale of the Heiji Rebellion) and the *Mōko Shūrai Ekotoba* (The Mongol Invasion), survive; most others, such as the *Hōgen E* (The Hōgen Civil War) and the *Heike Yashima Kassen E* (The Heike Battle at Yashima) have been lost. Poetry *(waka)* scrolls do not display the narrative quality of other *emaki,* but rather illustrate the popular medieval Japanese pastime of composing thirty-one-syllable poems. Each poem in such a scroll is illustrated by a scene, usually a landscape related to the poem, or by a portrait of the poet. Documentary *emaki* record historical events, festivals, and ceremonies— one example is the *Nenjū Gyōji Emaki* (Annual Rites and Ceremonies).

Although illustrated handscrolls are now known as *emaki* (or *emakimono),* in earlier centuries they were not distinguished from other forms of painting. Literary sources indicate that the *Genji Monogatari Emaki* was called simply *Genji E,* or "Genji Painting," and that the names of other scroll paintings merely added the suffix *e* to indicate "picture, illustration." It was not until the late Edo period (1603–1868), when this form of art had experienced a decline in real vitality and originality, that the term *emaki* came into existence. It may have been devised to distinguish the genre from the hanging scrolls *(kakemono)* that were popular throughout the Edo period, for *emaki* and *kakemono* differ considerably in form and content. Today a variety of descriptive terms are employed to distinguish among the types of *emaki: monogatari emaki* illustrate a narrative *(monogatari)* such as a novel or story or historical account in literary form; *nikki emaki* illustrate a diary *(nikki).* In the *ekotoba* (literally, "picture and word"), text and illustrations alternate. A picture album or a series of sketches, usually connected by a common theme, is known as a *sōshi* (often *zōshi* in compounds). Among scrolls with religious themes, *engi* (a term that literally means "dependent origination" and refers to the Buddhist doctrine of cause and effect) deal with the legendary origins of shrines or temples. *Eden* are the pictorial biographies of important historical personages, usually monks and priests. There are also the *kasen emaki,* poetry scrolls with portraits of the poets, and *uta-awase emaki,* handscrolls with scenes of poetry contests.

The *emaki* is perhaps the most representative expression of *yamato-e,* a rather vague term referring to paintings depicting Japanese subjects and scenes and inspired by Japanese sentiments. Yamato, the area south of the old capital of Nara, is considered the heart of the Japanese nation. *Yamato-e* or "Yamato painting" therefore means Japanese-style painting or "painting in the Japanese manner" and stands in contradistinction to *kara-e,* "Chinese-style painting." *Kara-e* came into Japan as part of the wholesale importation of Chinese culture that began in the mid-sixth century and was formalized after Prince Shōtoku established diplomatic relations with Sui China in 607. Continental influence, both that of Chinese Buddhist culture as well as that of the secular arts, was strong until the ninth century, and throughout this period the model for painting was *kara-e.* The Chinese persecution of Buddhism in the mid-ninth century, however, served to confirm Japanese fears that the T'ang dynasty (618–907), once so admired and emulated, was crumbling. As they have often done after a period of considerable borrowing from abroad, the Japanese turned inward and discontinued diplomatic relations with China in 894. They soon found expression for their sentiments and feelings in a literature and art in which vestiges of T'ang influence were incorporated into an increasingly native style. Japanese authors had long written in Chinese; now they began to explore their own language, using the newly created phonetic syllabary *(kana).* In the field of painting, *yamato-e* was free to develop.

While there are no surviving examples, numerous references to painting in the Japanese style *(yamato-e)* can be found in tenth- and eleventh-century Heian literature. We know that *kana* poems from Heian-period anthol-

ogies were often inscribed and illustrated on screens and sliding doors; these were presumably the earliest expressions of *yamato-e*. Many of the poems dwell on the beauties of Yamato and on the Japanese love for their homeland and were almost certainly complemented by paintings of Japan. Other subjects of these illustrated poems include the occupations of the twelve months of the year *(tsukinami-e)*, views of famous scenic sites *(meisho-e)*, and scenes of the four seasons *(shiki-e)*. But it was for the *monogatari-e* or "story paintings" which developed in the Heian period that the *emaki* format proved eminently suitable.

By the twelfth century *yamato-e* had reached its maturity. One of the earliest extant scroll paintings, *The Tale of Genji* (c. 1120–40), is a superb example of the courtly or *onna-e* ("women's painting") style of *yamato-e;* this formal, decorative style is characterized by a highly stylized, nondescriptive treatment of faces; the convention of showing interior scenes by removing the roof; a highly sophisticated sense of color harmony; exploration of the potentials of pure abstraction in form; and the use of parallel diagonal lines and a high-level viewpoint in composition. Yet such *emaki* are not limited to works in color; some are drawn in black ink alone. And in contrast to the quiet, relatively static scenes of court life, there are *emaki* whose quick, fluid brushstrokes and integrated narrative composition emphasize lively action and vivid characterization. Buddhism, and to a lesser degree Shintoism, often provided the inspiration for these *otoko-e* ("men's painting") *emaki*, which can take the form of dramatic chronicles of the founding of a Buddhist temple or Shintō shrine or of stories with a religious moral. Whereas courtly *emaki* deal exclusively with the lives and concerns of the nobility and seldom show anyone of low rank, the noncourtly *otoko-e emaki* often show an interest in the boisterous life of the lower classes, who are depicted with a humor that sometimes borders on caricature.

The term *yamato-e* connotes not only a departure from the subject matter of *kara-e* but also a different way of interpreting the world. The Japanese seem to have a fundamentally more emotional, less philosophical and intellectual approach toward life and art than do the Chinese. The Japanese tend to view painting more personally and more as decoration; hence their fascination with color and with abstract form. This is not true for all periods and styles in Japanese art history, but it certainly characterizes *yamato-e,* and within *yamato-e,* the *emaki* tradition.

Narrative Picture Scrolls

Historical Development

In *emaki* art, as in so many of its cultural expressions, Japan both borrowed and created: the impetus came from the Asian continent, but the inventive genius that transformed the continental handscrolls and narrative art forms into the vital, colorful *emaki* was purely Japanese. To trace the development of *emaki* is also to trace the convergence of outside influences on Japan and their assimilation into a new cultural synthesis.

The Heritage of China

Although *emaki* developed along distinctly Japanese lines, they have roots in Chinese secular arts and in the Buddhist tradition. The earliest surviving secular narrative arts in China are the paintings and bas-reliefs that cover the walls of Han-period (206 B.C.–A.D. 220) tombs, such as the ones in Manchuria at Liao-yang and those in Shantung Province at the Wu Liang Tz'u shrine. These long, running narrative compositions depict scenes of court nobles, acrobats, musicians, jugglers, dancers, and servants. The tomb decorations emphasize the human figure and scenes of contemporary life, reflecting a taste that probably characterized wall paintings in Han palaces and temples.

Among the various forms of narrative art from the ensuing dynasties up to the T'ang period, only tomb decorations survive in abundance. There is also, however, a copy of a handscroll by the famous Eastern Chin period painter Ku K'ai-chih (A.D. 344–406), now in the British Museum in London. His *Admonitions of the Instructress to Court Ladies* is an example of a hand-

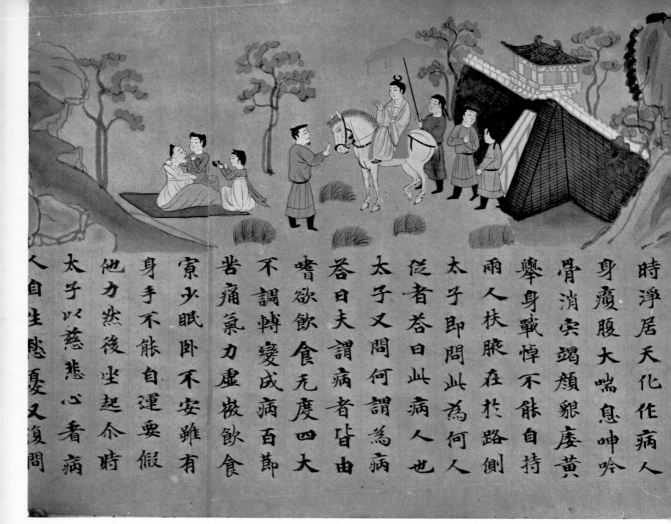

人自生愁憂又復問
太子以慈悲心看病
他力然後坐起余時
身手不能自運要假
宗少眠臥不安雖有
苦痛氣力虛羸飲食
不調轉變成病百節
嗜欲飲食无度四大
答曰夫謂病者皆由
太子又問何謂為病
從者答曰此病人也
太子即問此為何人
雨人扶腋在於路側
擧身戰悼不能自持
骨消肉蹙顏貌痿黃
身癭腹大喘息呻吟
時淨居天化作病人

1. E Inga-kyō. Nara period, 8th century. Jōbon Rendai-ji, Kyoto.

scroll from the Chinese secular tradition that shows elements which later became part of the courtly or *onna-e* style of *yamato-e*—a distinctive treatment of spatial perspectives in interior scenes (using diagonal parallel lines of recession), figures that are large in scale and provide the focus of attention, themes based on human relationships and activities, and an overall impression of static, decorous realism, broadly painted and brightly colored. The oblique, downward-looking vantage point so characteristic of *emaki* in the courtly tradition had become well established in Chinese painting by the T'ang period.

The Buddhist Narrative Tradition

Narrative techniques have an important place in the Buddhist artistic tradition as well. One beginning for this tradition is found in India in about the first century A.D.: the narrative friezes on the gateway to the great reliquary mound *(stūpa)* at Sanchi in central India depict episodes from the life of the founder of the faith, Gautama Buddha (c. 563–483 B.C.)

As Buddhism spread, so did Buddhist narrative art. Continuous compositions illustrating the lives and deeds of Buddhist holy figures are found in India, Central Asia, and China. Three famous Buddhist cave temple sites in China provide a rich treasury of Buddhist narratives. These sites are at Tun-huang in northwest Kansu Province, at the eastern end of the Silk Road; Yün-kang in Shansi Province; and Lung-men in Honan Province. The wall paintings of Tun-huang, which date from the mid-fifth through the tenth cen-

2. *"The Law,"* Genji Monogatari Emaki. *This highly emotional scene shows the hero Genji visiting his dying consort Murasaki no Ue. Although their abstract features give no sense of strong feeling, they both hold their sleeves to their faces, an artistic convention used to indicate weeping. On the left are somber autumn plants swaying in the wind, adding to the mood of this tragic scene. The farewell* waka *poems Genji and Murasaki no Ue exchange reflect their heartfelt melancholy that life is as transient as the dewdrops on these plants. In the lower right-hand corner the figure of Empress Akashi, Genji's daughter by another woman whom Murasaki no Ue had adopted, can be seen from behind. Heian period, 12th century. Gotō Art Museum, Tokyo.*

turies, serve as the greatest single source of Buddhist narrative art in China. If the lengths of all the wall paintings of the three "Thousand Buddha Caves" of Tun-huang were added together, they would extend for twenty-five kilometers. Many of these wall paintings present static, *mandala*-like scenes depicting the hierarchies of Buddhist divinities. There were, however, some architectural conventions in the Tun-huang paintings, in which events set in enclosed courtyards were seen from a bird's-eye viewpoint, that may have provided a model for *emaki* artists. But it was left to the Japanese genius to remove arbitrarily the roofs and ceilings of buildings in order to provide a direct view into interior scenes.

Embassies, including artists and monks as well as merchants and officials, traveled back and forth be-

tween China, Korea, and Japan from the mid-sixth century on. They carried with them books and paintings as well as religious doctrines, political systems, and all the other appurtenances of culture that enabled the Japanese to absorb and imitate continental civilization.

The Emaki in Japan

The oldest extant *emaki* in Japan are those of the *E Inga-kyō* (Illustrated Sutra of Cause and Effect), which date from the mid-eighth century. These are Japanese copies of early sixth-century illustrated Chinese handscrolls based on the *Kako Genzai Inga-kyō* (Sutra of Cause and Effect of the Past and Present), which treats the former existences of the historical Buddha

3. Genji Monogatari Emaki. *Heian period, 12th century. Tokugawa Art Museum, Nagoya.*

4. Genji Monogatari Emaki. *Heian period, 12th century. Tokugawa Art Museum, Nagoya.*

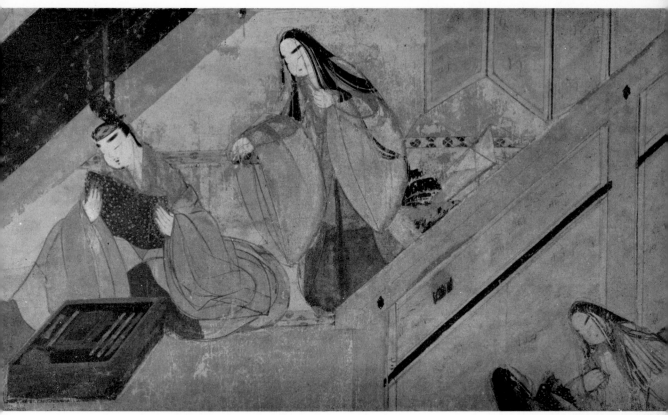

5. Genji Monogatari Emaki. *Heian period, 12th century. Gotō Art Museum, Tokyo.*

as well as the legends of the life in which he attained final enlightenment. During the Nara (646–794) and early Heian (794–897) periods, the Japanese eagerly absorbed every aspect of Buddhist culture imported from China. They were desirous, moreover, of assimilating not only Buddhist but secular culture as well, and it is very possible that secular illustrated handscrolls were also imported from T'ang China at the same time. These T'ang handscrolls are known to have depicted historical events, contemporary customs and genre scenes, court life, Taoist and Buddhist personages, landscapes, and animals.

The beginnings of *emaki* art in Japan must have been devoted to the reproduction of these Chinese handscrolls. The Japanese developed their skill by copying Chinese prototypes, and when influences from the mainland were no longer strong, artists utilized the *emaki* format to depict Japanese landscapes and stories and concerns.

• THE BEGINNINGS (tenth through early twelfth centuries). The hundred-year span from the early tenth to the early eleventh century proved to be the germinative stage for a new Japanese culture centered on the lives of the aristocrats residing in the capital of Heian (present-day Kyoto). The emperor was the nominal head of the government, but in reality the noble Fujiwara clan, who aligned themselves closely with the imperial house by marrying their daughters to the emperors, gradually assumed almost complete political control. The Fujiwara ruled by their political influence and by their wealth rather than by military strength,

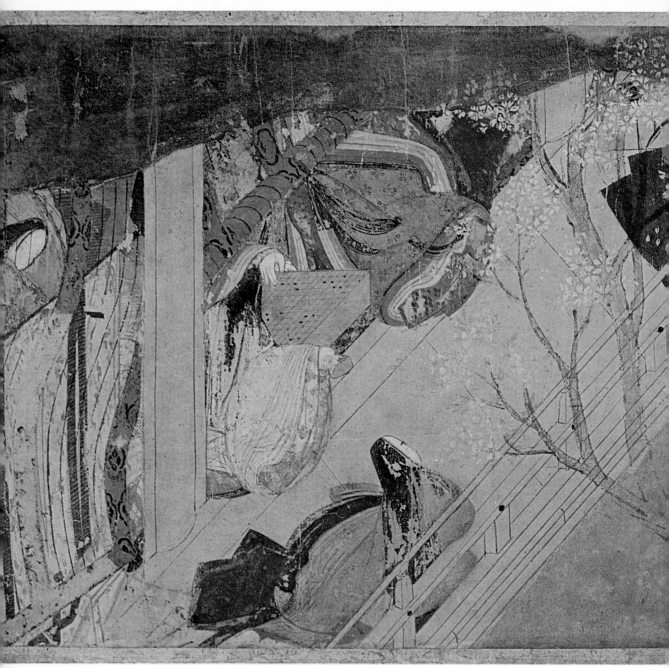

6. "*Bamboo River*," Genji Monogatari Emaki. *The subject of this scroll painting, aristocratic life in the eleventh-century Heian court, is portrayed here in a manner that effectively conveys the sedentary, closed atmosphere that was its hallmark. Features are stylized in the* hikime-kagihana *technique, and there is an emphasis on abstraction—on form and color rather than realistic characterization. On*

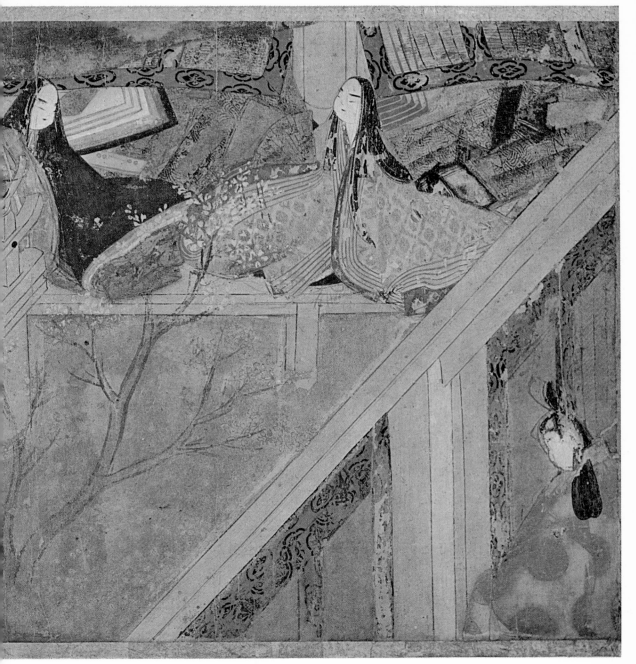

the extreme right Kurōdo no Shōshō peers through some screens at the daughters of Tamakatsura, who are playing a game of go on the veranda of their house; the stake of their game is the blossoming cherry tree in the courtyard. Heian period, 12th century. Tokugawa Art Museum, Nagoya.

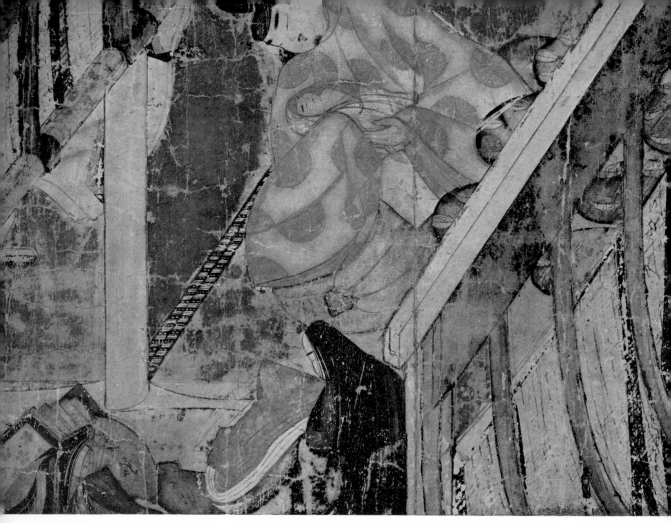

7. Genji Monogatari Emaki. *Heian period, 12th century. Tokguawa Art Museum, Nagoya.*

and they were great patrons of the arts. The most illustrious member of the clan was Fujiwara Michinaga (966–1027), during whose regency the most celebrated literary works of the age—*The Tale of Genji* and *The Pillow Book*—were written. This literature was written in the new Japanese syllabary called *kana,* which had been developing since the ninth century. Because of *kana,* writers and poets—many of them women—were freed from the necessity of having to write in Chinese, which remained the official language, and they could express the sensibilities and concerns of their age in their native tongue. This trend toward a new, typically Japanese culture is seen not only in literature, but in calligraphy and painting as well.

Emaki produced during this early period, however, no longer exist, and we have to depend on literary works and the collections of *waka*—lyrical, thirty-one-syllable poems written in Japanese—for evidence of their importance. The eleventh-century *Tale of Genji,* for example, is an extremely valuable source of cultural and artistic history. The world's first great novel, it was written by Murasaki Shikibu, a lady-in-waiting at the court of Empress Akiko, and describes the lives and particularly the amorous adventures of its hero, Prince Genji, and his descendants with great detail, sensitivity and psychological insight. Murasaki tells us that *emaki* were not only appreciated by the nobility but were painted by them as well, and she describes the kinds of *emaki* that existed in those days: illustrated diaries, landscape scrolls of the twelve months of the year, illustrated scrolls of monthly events, and illustrated scrolls of annual rites and ceremonies.

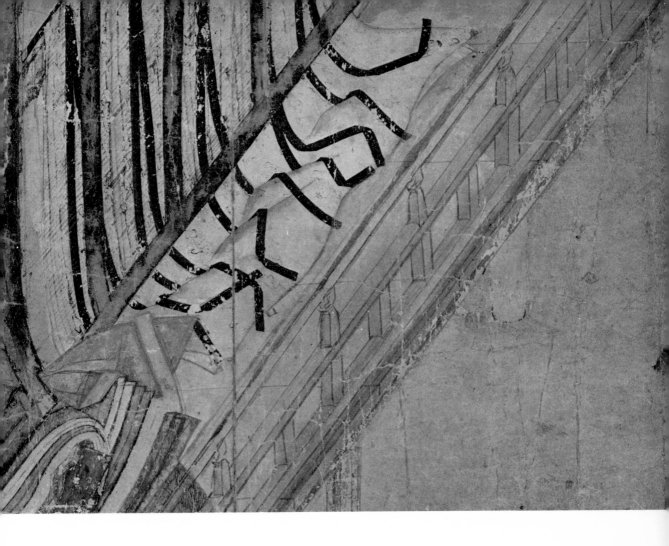

There were handscrolls based on literary works such as the ninth-century *Taketori Monogatari* (The Tale of the Bamboo Cutter), the oldest work of fiction in Japanese; the *Utsubo Monogatari* (The Tale of Utsubo); and the *Ise Monogatari* (The Tales of Ise); there were also scroll paintings illustrating the new manners and customs of the period. Although most *emaki* deal with Japanese themes and scenes, some depict Chinese historical events such as the story of Wang Chao-chün, a beautiful court lady of the Han period who was forced to marry the leader of the Huns, the barbarian enemies of the Chinese in the north.

The author of *The Tale of Genji* describes the *emaki* of those days as "dazzling to the eyes." This resplendent quality was no doubt in part a result of the elegantly decorated paper, braided silk cords, and costly covers that were used—all elements of *emaki* carefully described in the novel. She writes of the scroll paintings based on literary works that "they are superior to other scrolls because the pictures are exquisite and charming"; she remarks through one of her characters that "the pictures that illustrate literary works deserve attention." These statements very likely represent common opinion of the period, and we have every reason to assume that most of the *emaki* produced at this time were illustrations of literary works.

One distinctive spirit underlying much of this literature and, by extension, the *emaki* that illustrated it is termed *mono no aware*. *Mono no aware* is the association of beauty and sorrow, the recognition that what is beautiful is also pathetic because it is inevitably transitory and doomed to disappear. A sense of gentle

◁ 8. Genji Monogatari Emaki. *This scroll painting includes some of the most exquisite sections of calligraphy found in* emaki. *Paper decorated with gold and silver dust as well as strips of gold and silver was used. Textual portions written in the native Japanese syllabary (kana) in a loose and flowing style always precede the pictorial illustrations they describe, and often narrate parts of the story that are not illustrated. To the Japanese sense of aesthetics, calligraphy was not just a means of conveying a message, but was an art form worthy of the highest respect and requiring the most sophisticated training. Paper on which calligraphy was executed was carefully chosen, and at times, as is evident here, the paper itself was richly decorated. Heian period, 12th century. Gotō Art Museum, Tokyo.*

melancholy pervades most of the highly aesthetic and refined activities of the court nobles. Prince Genji cannot admire spring blossoms without lamenting the fact that soon they will fade and that death, for all of us, comes ever closer. He constantly talks of wanting to retire from the world and become a Buddhist monk (a conventional sentiment of the time).

This self-conscious and somewhat indulgent melancholy was not merely the expression of a luxurious and indolent way of life that occasionally became wearisome; there was also a growing belief in eleventh-century Japan that the period of Mappō, "the end of the Buddhist Law," was imminent. Events of the twelfth century seemed to bear out this dire prediction: there were provincial rebellions, droughts, famines, epidemics, fires, and a seemingly sudden increase

in robbery, murder, and suicide. The established Buddhist sects of Shingon and Tendai, with their complicated speculative doctrines and mystic ritualism, began to be superseded by a new popular cult centered on the transhistorical Buddha Amida, who offered release from pain through rebirth in his Western Paradise to all those who merely invoked his name.

Painting of the tenth century was, as we have seen, closely associated with contemporary literature; each complemented the other, and the viewer appreciated the atmosphere created by the blending of the two. In *emaki*, artists preferred the monoscenic form of composition, in which sections of text alternate with illustrations. The tendency to associate picture and text can also be seen on folding screens and sliding doors. A *waka* poem related to a painting was often written

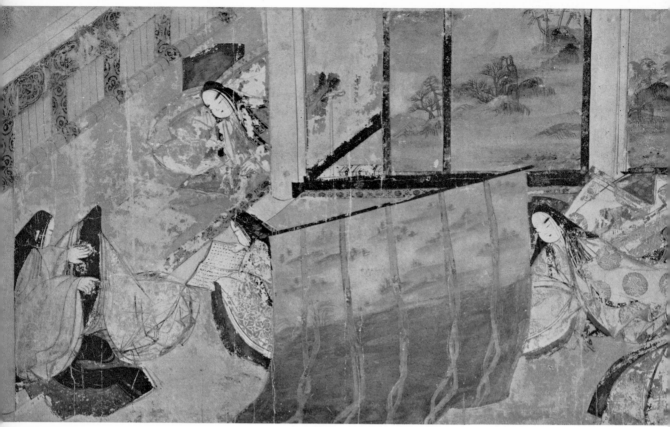

9. Genji Monogatari Emaki. *Heian period, 12th century. Tokugawa Art Museum, Nagoya.*

on a square piece of cardboard called a *shikishi* and pasted on a screen painting or sliding door. Sometimes the writing was even more closely tied in with the painting so that a synthesis of the two was created: In this case, the poem was written in such a way that the cursive *kana* characters fit into the picture and formed an image, such as the outline of a rock or plant. This technique is called *ashide-e,* which means literally "reed-hand painting." Devices of this sort no doubt also influenced *emaki* art of the period.

• THE DEVELOPING STAGE (the twelfth century). The aristocrats of Kyoto derived their economic wealth from large estates managed by a provincial gentry class of stewards and other officials that soon became a force to be reckoned with. During the eleventh cen-

tury, several emperors, in particular Gosanjō (1069–72) and his son Shirakawa (1072–86), attempted to limit the power of the Fujiwara clan. They were aided in this effort by various noble families that had been sent to the provinces to defend the frontiers against unconquered tribes.

The imperial house soon became dependent on these provincial clans, the most powerful of whom were the Taira (otherwise known as the Heike) and the Minamoto (or Genji). During the twelfth century, these two great clans struggled for supremacy. In 1159 the Taira were victorious under their leader Kiyomori, but after Kiyomori's death, two brothers of the house of Minamoto, Yoritomo and Yoshitsune, raised forces once again against the Taira. In the sea battle of Dannoura in 1185, the Minamoto utterly defeated the

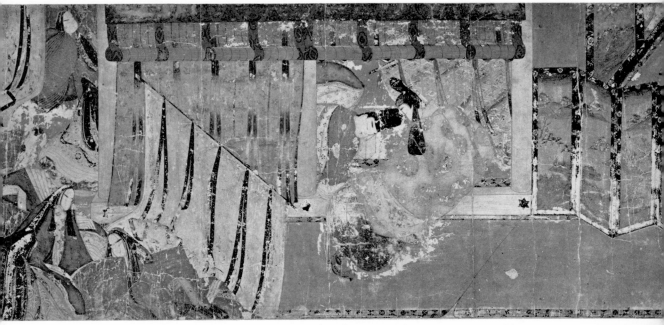

10. Genji Monogatari Emaki. *Heian period, 12th century. Tokugawa Art Museum, Nagoya.*

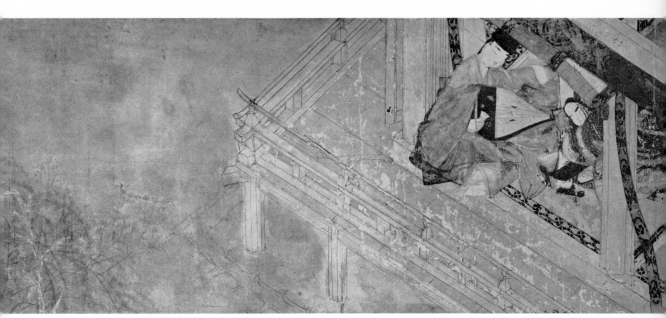

11. Genji Monogatari Emaki. *Heian period, 12th century. Tokugawa Art Museum, Nagoya.*

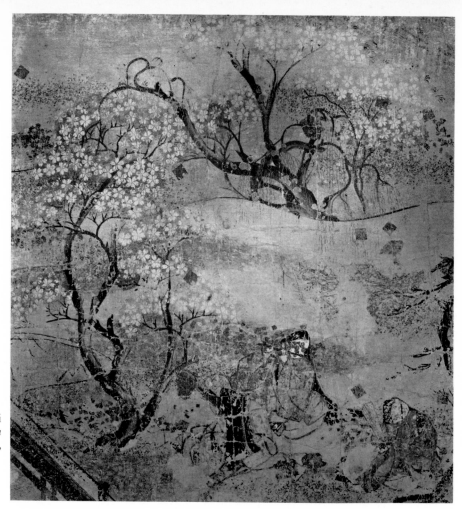

12. Nezame Monogatari
Emaki. *Heian period, 12th
century. Yamato Bunkakan,
Nara.*

Taira. Yoritomo proclaimed himself the *shōgun* (military dictator) of the country and moved the seat of government to Kamakura, a small village in eastern Japan that gave its name to the ensuing historical period. The emperors continued to live in Kyoto and remained the titular rulers of the country, but they were never able to wrest control of the government from the military leaders who stood at the apex of the emerging feudal social structure.

Emaki of the time reflect the changes that were taking place in the social and political structure of the country. Romantic scroll paintings based on literary works were gradually replaced by more dynamic narrative accounts that stressed the development of plot. A popular element was added to the repertoire of *emaki* as interest in the lives of the common people

increased: we are given glimpses into the lives of ordinary folk as well as those of aristocrats. And in addition to the traditional technique of building up images with heavy, opaque pigments that were then outlined in black, free-style drawing came to be used to sketch lively scenes in which movement was paramount.

Despite changes and new developments, a sense of nostalgia for the past is also a hallmark of this time. The *Eiga Monogatari* (Tale of Splendor), a forty-volume romanticized history of the imperial court written in the late eleventh century, and stories inspired by works like *The Tale of Genji* glorified an earlier time. Tradition also played a large role in art; artistic techniques were carefully handed down and preserved. Another, almost contradictory, aspect of the period was the per-

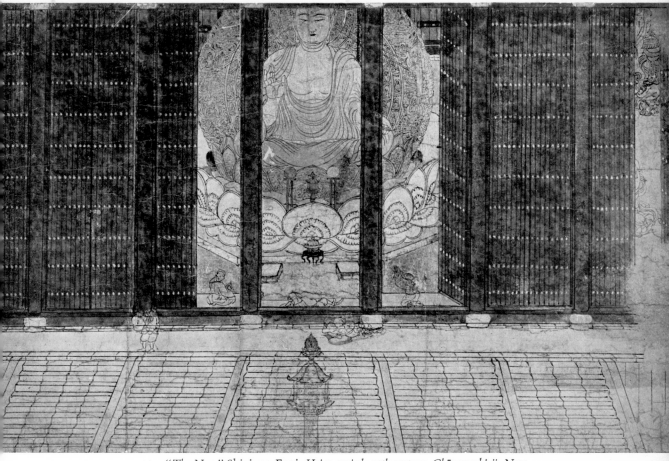

13. *"The Nun,"* Shigi-san Engi. *Heian period, 12th century. Chōgosonshi-ji, Nara.*

meation into aristocratic circles of a more popular culture. The nobles seemed to crave anything new. Popular entertainment from the lower classes, such as *sarugaku* and *dengaku,* humorous and often vulgar dance and song arrangements accompanied by drums and flutes, which were early forms of Nō drama, were performed before aristocratic gatherings. Stories of warriors and commoners, who had seldom appeared in literature before, as well as more frankly ribald accounts gained an increasingly wider audience.

Among these new works of literature was the *Konjaku Monogatari,* a thirty-one-volume collection of narratives in which people from all walks of life were treated as heroes. The fact that the aristocracy began to look to the lives of the common people for inspiration and entertainment indicates the decline of a

genuine patrician flavor in the culture at large. These two trends—namely, a respect for the past and an attention toward new concerns—helped create a variety of new and important *emaki.* Four masterpieces —the *Genji Monogatari Emaki* (The Tale of Genji), the *Shigi-san Engi* (Legends of Shigi-san Temple), the *Ban Dainagon Ekotoba* (Story of the Courtier Ban Dainagon), and the *Chōjū Jimbutsu Giga* (Scroll of Frolicking Animals and People)—all belong to this period.

In the *Genji emaki,* we see the style of the early period faithfully transmitted, though rendered in a highly refined manner. By contrast, the *Shigi-san* and *Ban Dainagon emaki* herald a new era and new styles. Unlike the *Genji emaki,* which depicts events from classical literature of court origin, the *Shigi-san Engi* illustrates the legendary miracles performed by a Bud-

14. "The Flying Granary," Shigi-san Engi. Heian period, 12th century. Chōgosonshi-ji, Nara.

dhist monk named Myōren. The scroll painting itself probably dates from the middle decades of the twelfth century. It stands as a counterpart to the *Genji emaki* not only in content, but also in form. The *Genji* handscrolls are characterized by alternating textual and pictorial portions, whereas the *Shigi-san Engi* contains only four textual sections in its three scrolls; the narratives are depicted in the form of a continuous composition in which one scene moves effortlessly into the next. Unlike the *Genji emaki,* which is painted with the heavy, opaque pigments of the *tsukuri-e* technique, the *Shigi-san Engi,* which is faintly colored, stresses line drawing to depict the swiftly moving events. Its setting is wider in scope as well: there are landscapes and outdoor scenes, and the interior views to which scrolls such as the *Genji emaki* are limited are not seen at all.

The *Ban Dainagon Ekotoba,* which dates from the second half of the twelfth century, employs the styles of both the *Genji* and *Shigi-san* scrolls and emphasizes color and line drawing. In terms of content and form, however, the *Ban Dainagon emaki* is much closer to the *Shigi-san Engi:* it is a continuous composition over twenty feet long that devotes itself to the unfolding of a dramatic story. Although the *tsukuri-e* technique is used, the artist has also employed free-style drawing to add movement and vitality to the hundreds of figures he portrays. The *Ban Dainagon Ekotoba* goes a step further than the *Shigi-san Engi* in its treatment of individual figures and faces and in its sophisticated handling of crowd scenes.

The first scroll of the *Chōjū Jimbutsu Giga,* which probably dates from the second quarter of the twelfth century, differs from the other three scroll

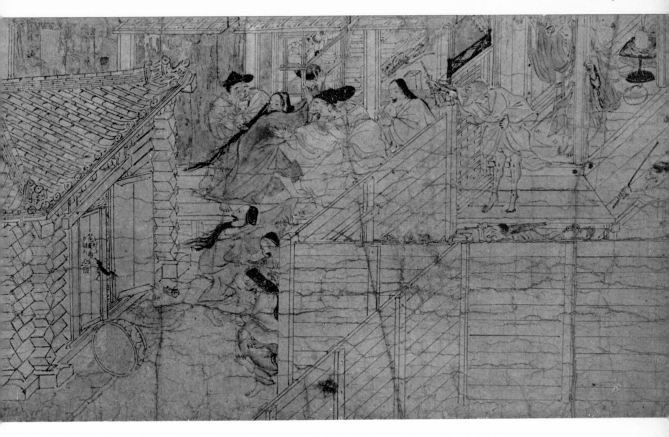

paintings in that it is executed in ink alone. This *emaki* depicts all sorts of playful animals who seem to be parodying human beings. A religious ceremony at the end of the first scroll (Plate 25) in which a monkey-priest prays before a statue of the Buddha in the form of a frog, for example, is clearly an essay in religious satire. The *Chōjū emaki* is no doubt derived in style and technique from Buddhist iconographic drawings executed in monochrome ink. Kōzan-ji, where it is preserved, was a center for this kind of drawing, and the scrolls may have been produced as a diversion by the monk-painters who worked in the temple atelier.

• THE MATURE STAGE (thirteenth to mid-fourteenth centuries). After Minamoto Yoritomo's death, power passed into the hands of the Hōjō clan, who were related to the family of Yoritomo's wife. The Hōjō regency, established in 1205, endured until 1333. One of its most significant accomplishments was success-fully fending off the attacks of the Mongols in 1274 and 1281. The militaristic spirit of the new ruling class was reflected in contemporary culture. Despite the fact that political and military power was centered in Kamakura, the cultural focus of the country was still Kyoto, where the traditional arts continued, now vital-ized by the new more realistic and vigorous currents.

One of the most important cultural developments of the period was the rise of popular Buddhist salva-tion sects in response to social unrest and to the de-terioration of the previously powerful religious sects. Hōnen Shōnin (1133–1212) founded the Jōdo or Pure Land sect; his disciple Shinran Shōnin (1173–1262) carried his master's reforms still further and established the Jōdo Shinshū or True Pure Land sect. Ippen Shō-

15. "The Nun," Shigi-san Engi. Heian period, 12th century. Chōgosonshi-ji, Nara.

nin (1239–89), a peripatetic singing and dancing monk, founded yet another Pure Land sect, the Jishū or Timely sect. Still another popular sect was established by Nichiren (1222–82), a fanatic and nationalistic devotee of the Lotus Sutra (Hoke-kyō). The Zen sect was also formally introduced from China and established in Japan in the beginning of the thirteenth century, but Zen, with its emphasis on meditation and self-discipline, appealed more to the warriors than to the mass of common people. These new sects were important for yet other reasons: they motivated the older sects, such as those of Tendai and Shingon, to reform, and in their doctrines and guiding personalities they provided a new source of inspiration for emaki art.

During the Kamakura period (1185–1336), emaki art, reflecting the contemporary cultural and social changes, increased in complexity both in content and in style. A focus on explanatory narration superseded the earlier emphasis on decoration, and realistic concerns supplanted the older abstract designs and romantic tone. Monks as well as samurai warriors and the hereditary nobility became patrons of emaki. During the late Heian period most emaki had been produced by professional court painters supervised by the court bureau of painting (Kyūtei Edokoro), but during the Kamakura and ensuing Muromachi periods, emaki production took place more and more in temple and shrine workshops (jiin-edokoro), at the hands of professional monk-painters. The production of emaki steadily increased, and the thirteenth century is considered the golden age of this art form.

16. "The Flying Granary," Shigi-san Engi. Scroll I. This handscroll is popular not only for its entertaining content, but also for its lively artistic execution. The first scroll, a section of which is shown here, concerns a magic golden begging bowl that belongs to the monk Myōren. Myōren, rather than descending from his home on Mount Shigi, sent his bowl directly to the granary of a rich man. One day, however, the servants neglected the bowl and left it unfilled in the granary, whereupon it slipped out under the building and flew off, carrying the whole building and all the stored-up rice bales with it. In this scene the building flies by, supported by the bowl, to the astonishment of passers-by. Heian period, 12th century. Chōgosonshi-ji, Nara.

A wide variety of secular *emaki* included illustrated literary works, *waka* poems, narrative accounts, war chronicles, and documentaries. *Emaki* based on literary works retained the aestheticism associated with the court and court society. Many were created out of a sense of nostalgia—to commemorate the glorious court life of an earlier age and to pay homage to classical literature. Extant *emaki* of this group include the *Murasaki Shikibu Nikki Emaki* (Diary of Lady Murasaki), the *Ise Monogatari Emaki* (Tales of Ise, Plate 86), the *Hazuki Monogatari Emaki* (Tale of Hazuki, Plate 85), the *Komakurabe Gyōkō Emaki* (An Imperial Visit to the Horse Race), the *Ono no Yukimi Gokō Emaki* (The Imperial Visit to Ono for Snow Viewing, Plate 72), the *Toyo no Akari Ezōshi* (Scroll of Toyo no Akari, Plates 70 and 71), the *Makura no Sōshi Emaki* (The Pillow Book), and the *Nayotake Monogatari Emaki* (Tale of a Young Bamboo).

The *emaki* illustrating *waka* poems, poets, and poetry meetings were also of court origin and inspiration, and reflected the immense popularity of *waka* poetry at the time. Among these works were the *Sanjūrokkasen Emaki* (The Thirty-six Poetic Geniuses), the *Ise Shin Meisho Uta-awase Emaki* (Poetry Contest on Newly Selected Scenic Spots in Ise), and *Tōhoku-in Shokunin Uta-awase Emaki* (Tōhoku-in Poetry Contest Among Members of Various Professions).

Literary sources tell us that a large number of *emaki* depicting war chronicles was created at this time, although most of them have since been lost. They reflected the developing samurai ethic and illustrated popular and often gory war accounts, for the civil

17. "The Nun," Shigi-san Engi. *Heian period, 12th century. Chōgosonshi-ji, Nara.*

wars that had racked the country at the end of the Heian period provided a fertile source of inspiration for both literature and art. *Emaki* of this type that have come down to us include the *Heiji Monogatari Emaki* (The Tale of the Heiji Rebellion), the *Gosannen Kassen Ekotoba* (The Gosannen Battle, Plate 81), and the *Mōko Shūrai Ekotoba* (The Mongol Invasion).

Emaki of a documentary nature dealing with either historical events or portraits of people of historical significance were created under the influence of the realistic trend in portraiture *(nise-e)*. Existing *emaki* of this sort include the *Zuijin Teiki Emaki* (The Imperial Guard Cavalry), the *Kuge Retsuei Zukan* (Scroll of Portraits of Courtiers, Plate 48), and the *Tennō Sekkan Daijin Ei* (Portraits of Emperors, Regents, and Ministers, Plate 32).

Religious scroll paintings of the Kamakura period surpass in excellence even the finest secular *emaki*. With the exception of the eighth-century *E Inga-kyō* and the *Shigi-san Engi* of the late Heian period, religious *emaki* did not appear as a distinct subdivision of *emaki* art until this period. One impetus for their development was the emergence of new sects whose followers felt the need to record and illustrate the lives of the founders and to propagate the virtues of the new doctrines.

Both the religious and secular *emaki* of this period added a wide variety of characters to their repertoire. In addition to noblemen, people from all walks of life—including priests, samurai, farmers, fishermen, merchants, entertainers, and beggars—came to be depicted with humor and pathos. People from China,

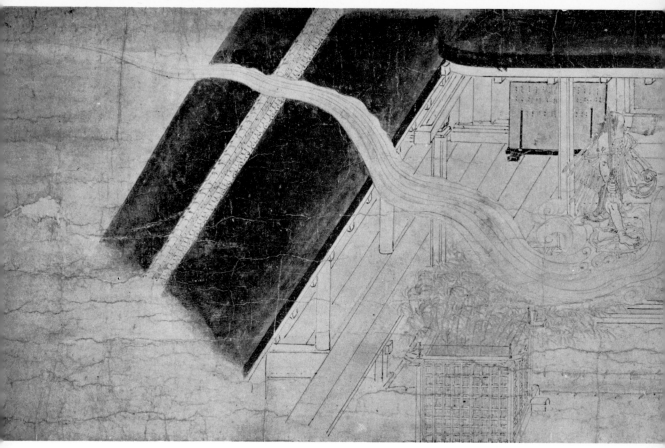

18. *"The Miraculous Cure of the Engi Era,"* Shigi-san Engi. *Heian period, 12th century. Chōgosonshi-ji, Nara.*

Korea, and Central Asia were portrayed in their native costumes. And cities, mountain villages, and the countryside, used as background settings for *emaki,* added much local color. Several *emaki* that exemplify the new interest in both narrative subject matter and the lives of commoners are the *Yamai no Sōshi* (Scroll of Diseases and Deformities), the *Kibi Daijin Nittō Ekotoba* (Minister Kibi's Visit to China), the *Eshi no Sōshi* (Story of a Painter), and the *Haseo-kyō Zōshi* (Tale of Lord Haseo).

• THE LATE STAGE (early fourteenth to late sixteenth centuries). In 1333, Emperor Godaigo, with the help of various nobles, overthrew the Hōjō family. One of his supporters, however, Ashikaga Takauji, turned against the emperor in 1335, seized Kyoto, installed another imperial prince as emperor, and made himself shogun. Godaigo fled south and established a court in the mountainous Yoshino district. The period of dynamic schism, called the Age of the Southern and Northern Courts, lasted until 1392, when the grandson of Takauji, Ashikaga Yoshimitsu, forced the southern emperor of the time to abdicate.

The Ashikaga family, whose period of rule (1336–1568) is often called Muromachi after the part of Kyoto in which they lived, moved the government there from Kamakura. By the fifteenth and sixteenth centuries, however, internecine warfare made it difficult for the Ashikaga to maintain control. The Onin War, which raged for ten years in the fifteenth century, resulted in the destruction of much of Kyoto. The next century, until the last Ashikaga shogun was deposed by

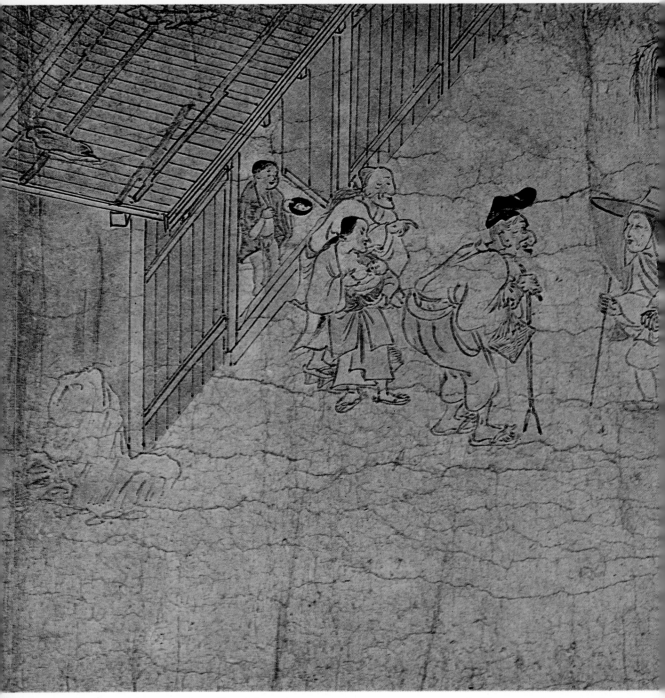

19. "*The Nun,*" Shigi-san Engi. *Scroll III. The monk Myōren's sister, a nun, sets out in search of her younger brother, who had left home over twenty years before. In this scene we see her on her way to Nara, wearing a broad straw hat and simple nun's garb. She stops an aged passer-by to tell him her story and ask if he knows the whereabouts of her brother, as those nearby listen on with interest. The*

scene is unencumbered with detail, and it is just this simplicity, marked by the use of quick, thin lines, that makes this handscroll so appealing. Since the individuals portrayed are commoners and not aristocrats, the artist was free to depict various facial expressions and gestures. Heian period, 12th century. Chōgosonshi-ji, Nara.

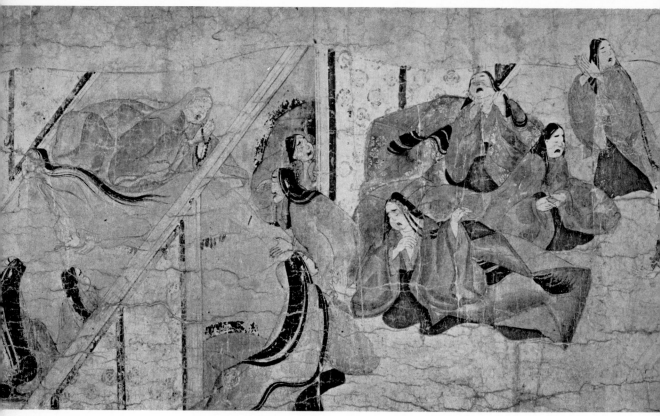

20. Ban Dainagon Ekotoba. *Heian period, 12th century. Sakai Collection, Tokyo.*

21. Ban Dainagon Ekotoba. *Heian period, 12th century. Sakai Collection, Tokyo.* ▷

Oda Nobunaga in 1573, is called Sengoku Jidai—Age of the Warring Provinces.

The *Kasuga Gongen Reigen Ki* (The Kasuga Gongen Miracles) is considered representative of *emaki* created during the transitional stage between late Kamakura and early Muromachi times. After the production of this work, however, *emaki* art succumbed to the trap of mannerism and lost a great deal of its charm and vitality. The deterioration, which went on as *yamato-e* declined in popularity, resulted in large part from the introduction of Chinese monochrome ink landscape paintings of the Sung and Yüan dynasties. This Chinese style of ink painting found favor among the new warrior-aristocrats in Kyoto who had become the arbiters of taste.

Emaki illustrating classical literature, *waka* poems, and poetry contests were gradually replaced by scroll paintings depicting *otogi zōshi* (folk tales). *Otogi zōshi*, written mainly during the Muromachi period, concerned common people, not the nobility; their themes range from various aspects of love to the supernatural and mysterious. The tales are recreational and illuminative, and often ethical and religious as well. Most emphasize plot, and some are extremely humorous. Many *emaki* illustrating *otogi zōshi* must have been made, because a great number of scrolls survive. Although all are anonymous, it seems likely that they were produced not only by artists of the orthodox schools of painting but also by *machi-eshi* (town painters), free-lance popular artists who were often trained

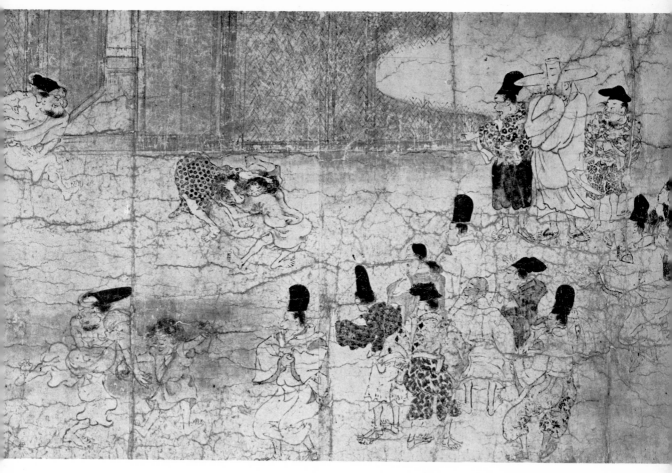

in professional workshops and who then established themselves independently.

Historical sources of the period, such as the *Sanetaka Kōki*, the diary of the courtier-scholar Sanetaka (1474–1536), inform us that the court nobles and the Ashikaga shoguns were among the first admirers of the folk-tale scrolls. But these *emaki* must also have gained the favor of the public at large, and *machi-eshi* probably produced some of them on commission for rich commoners. *Otogi zōshi emaki* are often immature and crude in style, but they also express an attractive and charming naiveté not seen in traditional works. Unable to maintain their popularity, however, they were in time replaced by the *nara ehon,* handmade picture books that became popular during this period.

Despite the work of the later *machi-eshi,* it is important to remember that the *emaki* was essentially an aristocratic tradition. Noblemen were accustomed to commissioning *emaki* of a literary nature for themselves and religious *emaki* to give to temples and shrines in order to gain spiritual merit. Temples and shrines themselves commissioned *emaki* depicting their origins or the virtues of their founders and principal deities. These temple *emaki* were carefully guarded and preserved and shown only to honored guests.

Emaki continued to be produced during the Muromachi period and during the ensuing Momoyama (1568–1603) and Edo (1603–1868) periods. They were, however, inferior in quality to those of the Kamakura period, and far fewer were made. After the

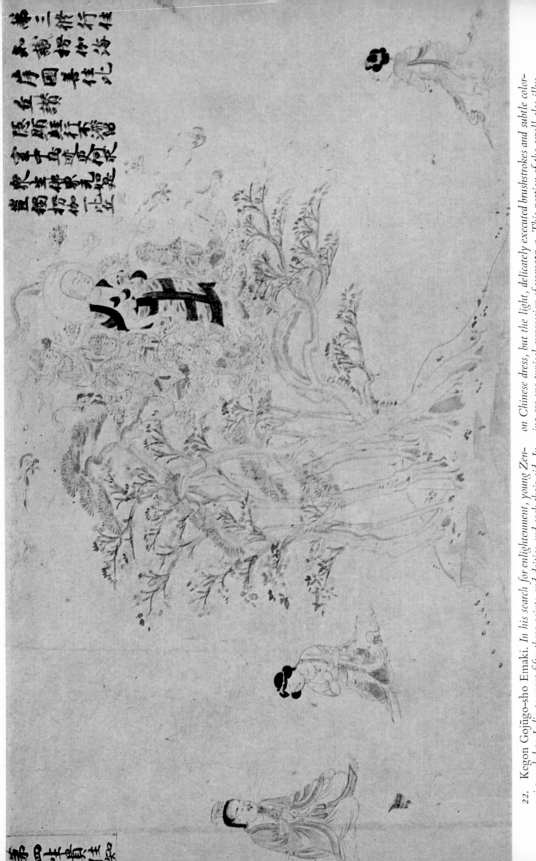

22. Kegon Gojūgo-sho Emaki. In his search for enlightenment, young Zenzai traveled to India to meet fifty-three saints and deities and seek their aid. In this portion of the scroll painting, Zenzai meets the Buddhist priest Zenjū at his seaside home and requests religious instruction. Zenjū is shown descending through the branches of trees, surrounded by angelic deities. The calligraphy in the upper right-hand corner gives the rank and name of the saint, the location of his abode, and a description of the scene. The clothing of the figures is modeled on Chinese dress, but the light, delicately executed brushstrokes and subtle coloring are one typical expression of yamato-e. This portion of the scroll also illustrates another device characteristic of emaki art—repeated depiction of main figures. After Zenzai, shown in the right foreground, meets Zenjū, he continues on his journey and is shown again at the left seeking advice from another wise man. Heian period, 12th century. Tōdai-ji, Nara.

23. Kegon Gojūgo-sho Emaki. *Heian period, 12th century. Tōdai-ji, Nara.*

sixteenth century, few *emaki* of any note were made.

Emaki art came into existence with the development of courtly narrative literature and a new national consciousness during the mid-Heian period, flourished as part of the *yamato-e* tradition under the patronage first of courtiers and then of warriors and temples, and finally declined as tastes changed. Designed to be appreciated by the leisured upper classes, the *emaki* became outdated as society increased in complexity and a rising middle class demanded less expensive, more accessible forms of art.

The Legacy of the Emaki and Yamato-e

Although the great age of scroll painting in Japan was over by the sixteenth century, the *yamato-e* tradition and the *emaki* continued to influence Japanese art. The Tosa school, which controlled the court academy during the late Muromachi period, was the ostensible transmitter of *yamato-e* in an age dominated by Chinese-style ink painting. The Kanō school was founded in the fifteenth century by Kanō Masanobu (1434–1530), who produced secular paintings in the Chinese manner. The marriage of Masanobu's son, Motonobu (1476–1559), to the daughter of the head of the Tosa school led to a fusion of the two chief art currents of the time. During the sixteenth century the Kanō school incorporated genre scenes, gold leaf, and bright color schemes to produce monumental decorative paintings that reflect the *yamato-e* heritage.

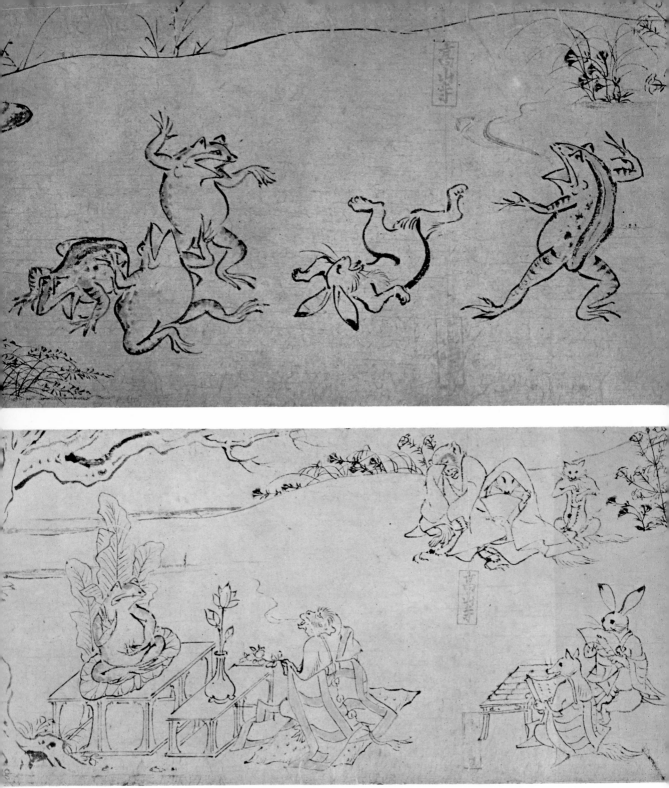

24–25. Chōjū Jimbutsu Giga. *Heian period, 12th century. Kōzan-ji, Kyoto.*

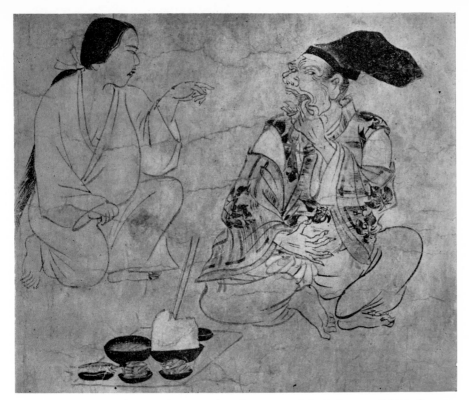

26. Yamai no Sōshi. *Kamakura period, 12th century. Sekido Collection, Aichi Prefecture.*

Other inheritors of the *yamato-e* tradition were Sō-
tatsu (active c. 1630) and Ogata Kōrin (1658–1716).
Influenced by the artistic and literary renaissance of
Japanese aristocratic taste, which was largely directed
by Hon'ami Kōetsu (1558–1637), Sōtatsu, who was
not only an artist in his own right but also a restorer
of ancient scrolls, borrowed themes from such hand-
scrolls as the *Genji Monogatari Emaki* and the *Saigyō
Monogatari Emaki* (Biography of the Monk Saigyō).
The inspiration for the energetic divinities that appear
on his large decorative screen *Fūjin-Raijin* (God of
Wind and God of Thunder), for example, could well
have been the storm gods found in the thirteenth-
century *Kitano Tenjin Engi* (Legends of Kitano Tenjin
Shrine) or the Muromachi-period *Kiyomizu-dera Engi*

(Legends of Kiyomizu-dera, Plate 113). His genius lay
in an ability to rework the themes and ideas of *yamato-
e* and the *emaki* into a uniquely personal and dynamic
style. Ogata Kōrin, in turn, was nurtured on the
classical arts of Japan; following in the footsteps of
his master Sōtatsu, he created works of great decora-
tive grace and distinction.

With the growth of a popular culture during the
Momoyama period came the development of yet
another type of art, genre painting, in which scenes
of daily life and customs form the major themes.
Although genre scenes were usually incidental in *emaki,*
certain types of Momoyama genre painting, such as
the representation of annual ceremonies and events
and outdoor entertainments, may be traced to earlier

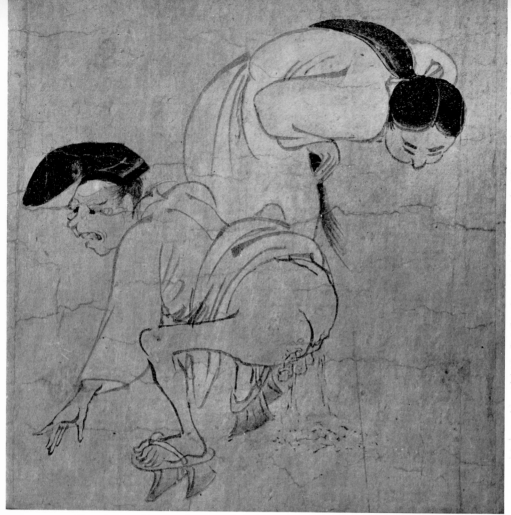

27. Yamai no Sōshi. *Kamakura period, 12th century. Sekido Collection, Aichi Prefecture.*

handscrolls. *Ukiyo-e* ("pictures of the floating world") developed in turn from Momoyama genre painting of domestic scenes, festivals, picnics, artisans, entertainers, and beauties. *Ukiyo-e,* which is largely known to the West through its woodblock prints from the Edo period, dealt with the pleasures of ordinary people and was created for the bourgeoisie, a new class of art patrons with a new aesthetic. The emergence of *ukiyo-e* represents the final flowering of ideals nurtured in the tradition of *yamato-e:* an unswerving interest in people and in the human world, colorful abstract design, a love of things intensely Japanese, and a personal rather than metaphysic view of nature and the universe.

2

Emaki as an Art Form

The *emaki* as an art form displays numerous ingenious techniques devised by artists to overcome the limitations and utilize to the fullest the advantages of the handscroll format. It is in the analysis of these techniques and styles that we begin to see not only the interplay between the kind of literature and the mode chosen for its expression, but also the way in which *emaki* illustrations reflect Japanese culture and the Japanese view of the world.

Artists

Only a few extant *emaki* bear the names of the artists who produced them and their dates of execution, and almost no mention is made of artists' names in old records. The long period during which *emaki* were produced and the number created suggest that there were a great many artists, but not until about the time of the painter Sesshū (1420–1506) did it become customary for Japanese artists to sign and date their work. (Some religious *emaki* are dated, it is true, but this is not the case with the overwhelming majority of the secular works.)

The few *emaki* artists known through literary sources and extant scrolls include not only professional artists, but people such as the emperor and his family, nobles, court officials, scholarly priests, and monk-painters. *The Tale of Genji* states that members of the imperial family and many aristocrats were *emaki* artists. During the Heian period the nobility received training in

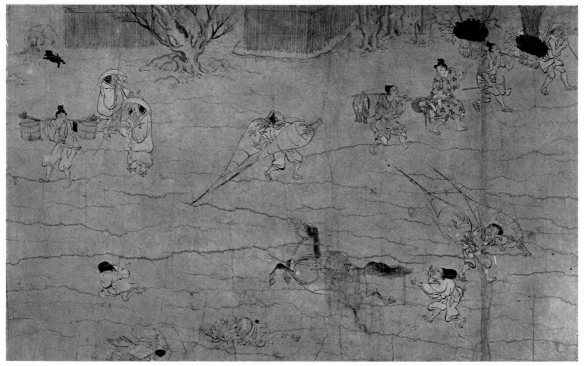

28. Saigyō Monogatari Emaki. *Kamakura period, 13th century. Ohara Collection, Okayama Prefecture.*

29–30. Saigyō Monogatari Emaki. *Kamakura period, 13th century. Ohara Collection, Okayama Prefecture.* ▷

painting and calligraphy as a matter of course, and many aristocratic "amateur" painters must have produced *emaki* of considerable merit. In fact, the dividing line between amateur and professional was very indistinct at this time.

The Tale of Genji also offers the names of some of the artists who actually lived and produced particular *emaki.* Kose Omi is reported to have painted the pictorial sections and Ki Tsurayuki to have inscribed the calligraphic portions of the *Taketori Monogatari Emaki* (Tale of the Bamboo Cutter), while Asukabe Tsunenori and Ono Michikaze are credited with the pictures and calligraphy, respectively, of the *Utsubo Monogatari Emaki* (Tale of Utsubo).

Most of the early professional artists were members of the Kyūtei Edokoro or the Bureau of Painting of the imperial court. Among them were Tokiwa Mitsunaga, Takashina Takakane, and Tosa Mitsunobu, who are said to have painted the *Ban Dainagon Ekotoba,* the *Kasuga Gongen Reigen Ki,* and the *Kiyomizu-dera Engi,* respectively. Some Buddhist monks were also professional artists; they painted religious pictures in the ateliers of their temples, and sometimes produced *emaki* as well. Shiba Rinken, the artist of the *Daibutsu Engi* (Legends of the Great Buddha), for example, was a Buddhist monk who was part of the Kōfuku-ji workshop in Nara. En'i, the artist of the *Ippen Shōnin* (Pictorial Biography of the Monk Ippen) scrolls, who worked in the Kankikō-ji, and Rengyō, who painted the *Tōsei Eden* (The Eastern Journeys of Ganjin), are also said to have been monks.

From late Muromachi times on there were, in ad-

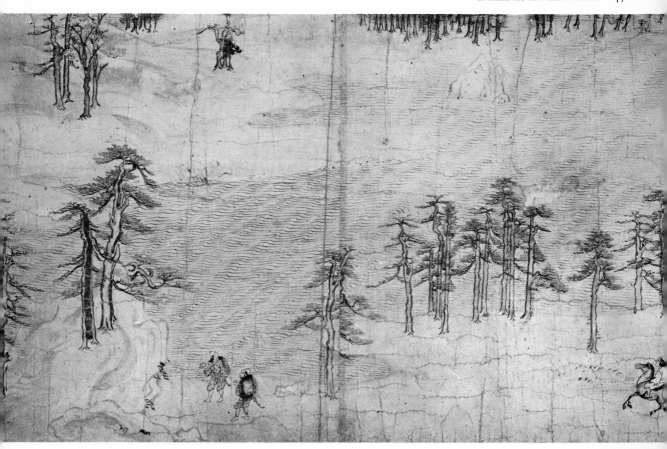

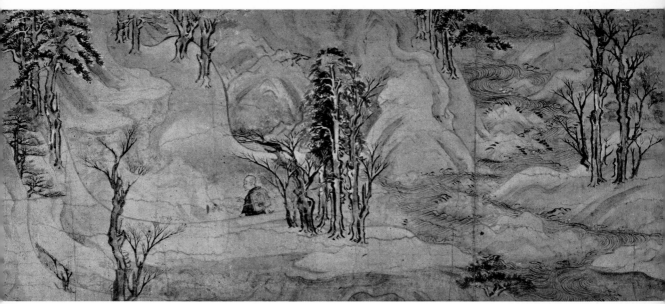

32. Tennō Sekkan Daijin Ei. *Kamakura period, 13th century. Imperial Collection, Tokyo.*

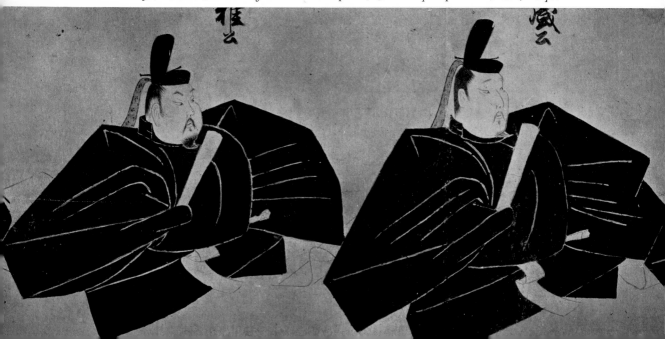

31. Sanjūrokkasen Emaki. *Kamakura period, 13th century. Fujiki Collection, Osaka.*

dition, free-lance artisan painters who had no connection with the imperial court atelier or with the various temple and shrine workshops. These unpretentious commercial artists, called *machi-eshi* or "town painters," developed and flourished along with the growth of the economy and of a prosperous merchant class which sought to satisfy a taste for the arts that had come with rising affluence. Court or temple ateliers were not open to commoners, but the *machi-eshi* would accept almost any sort of painting commission.

The work done by these small independent workshops varied in quality from the primitive and crude to the sophisticated and original. The well-known Kyoto workshop of Sōtatsu (c. 1630), for instance, not only copied *emaki* but was entrusted with the restoration and repair of fine old handscrolls. And it is thought that many folk-tale scrolls of the Muromachi period were created by unknown *machi-eshi*.

Style

Although many *emaki* defy rigid categorization, a broad stylistic distinction appears in the earliest surviving examples and reveals two different sources of inspiration. *Onna-e* ("women's pictures") *emaki* illustrate works of literature and are confined to depictions of court life; they are characterized by a quality of highly static stylization. *Otoko-e* ("men's pictures") *emaki,* on the other hand, are much more dynamic and full of action: these scroll paintings, which often illustrate adventure tales or legends, frequently take monks and commoners and even animals as their sub-

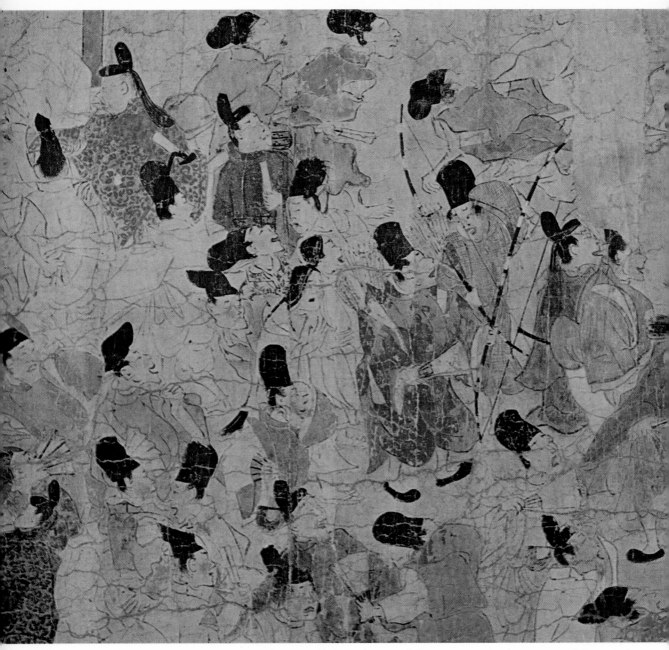

33. Ban Dainagon Ekotoba. *Scroll I. This scroll painting illustrates the story of the Great Councilor (Ban Dainagon) Tomo Yoshio, who set the Otemmon Gate in Kyoto on fire (on March 10, 866) and falsely accused another minister of arson; it is one of the outstanding examples of* otoko-e *(men's painting), a style marked by fast-moving narrative. In this scene, some people rush from the burning*

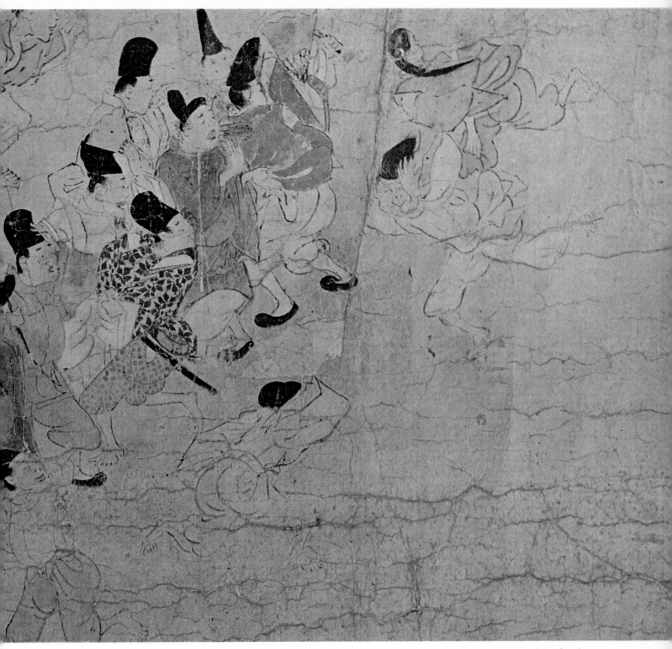

gate while others mill in horror at the spectacle. There is an impression of dynamic movement and excitement, and the facial expressions and variety of costumes and accessories provide interesting insight into the lives and dress of the people of the period. Heian period, 12th century. Sakai Collection, Tokyo.

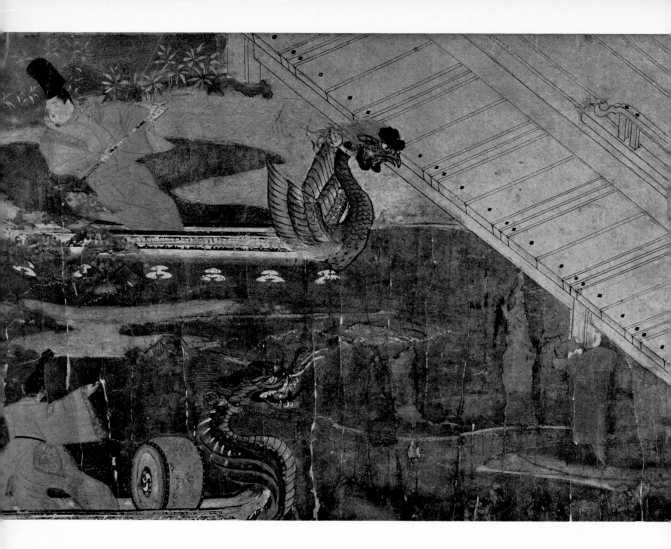

jects and are not confined to interior scenes within palaces. The clear distinction between these two styles began to fade in the late twelfth century, as *emaki* began to reflect social and political changes.

• ONNA-E. The *onna-e* or "courtly" *emaki* illustrate court society, particularly of the Heian period, and emphasize the refined, sedentary, yet emotion-filled life of the nobility. The illustrators of these *emaki* attempted to portray faithfully the overall aesthetic and lyrical effect of the original piece of literature on which the *emaki* was based rather than to depict the development of plot. Text and pictures alternate; the text introduces the scene that follows. Because the events bearing on a scene were explained in the text and were

generally well known to the courtly audience for whom these *emaki* were intended, it was deemed sufficient if the pictorial portion focused on only one important moment or emotion from the sequence of events. In other words, the pictorial portion did not have to bear the full responsibility for conveying the narrative.

The dreamlike quality of these *emaki* derives not only from their subject matter but also from the illustrative techniques employed. The stylized figures; the conventions for the depiction of emotion, both in face and gesture; the emphasis on decoration and abstract form, whether in color (the *tsukuri-e* technique) or in black and white; and the sense of confinement created by the representation of only limited interior

34. Murasaki Shikibu Nikki Emaki. *Kamakura period, 13th century. Fujita Art Museum, Osaka.*

(overleaf)
35. Gaki Zōshi. *A hungry ghost* (gaki) *is shown here sniffing the filth of a child-bed. Skillfully using the technique of* fukinuki-yatai, *the artist has removed ceilings and roofs to show two sections of a home. A number of attendants are admiring the newborn child while a priest waits in the adjoining room. Everyone seems delighted at the happy occasion; the* gaki, *who is invisible, passes unnoticed and perhaps seems all the more sinister for this very reason. Kamakura period, 12th century. Tokyo National Museum.* ▷

spaces all contribute to an atmosphere of remoteness from reality and a subtle, underlying feeling of highly charged emotion.

It is thought by some scholars that the *Genji* scroll painting, the earliest and most outstanding example of the courtly *emaki* style in color, is derived from *onna-e* produced and inspired by court ladies of the middle Heian period, who may themselves have devised the conventions for figures and facial features. In addition to the *Genji* handscrolls, *emaki* in the *onna-e* style include the *Nezame Monogatari Emaki* (Tale of Nezame), the *Murasaki Shikibu Nikki Emaki,* and the *Makura no Sōshi Emaki.*

• OTOKO-E. *Otoko-e emaki,* in marked contrast to the slow-paced *onna-e* handscrolls, often deal with non-aristocratic subject matter and concentrate on plot. The *otoko-e* style is marked by dynamism and freedom of movement: in these *emaki,* artists used rapid line drawing, a variety of background settings, and a realism close to caricature in facial and figural characterization to draw the viewer into the fast-moving narrative. The *Shigi-san Engi,* for example, is action-filled, dependent on plot, and replete with drama, as are the *Ban Dainagon Ekotoba* and the *Heiji Monogatari Emaki.* These three scroll paintings are all colored. Among monochrome *emaki* in the *otoko-e* manner, the *Chōjū Jimbutsu Giga* conveys the same lively, uninhibited effect through the use of rapidly drawn lines and continuous narrative sequences.

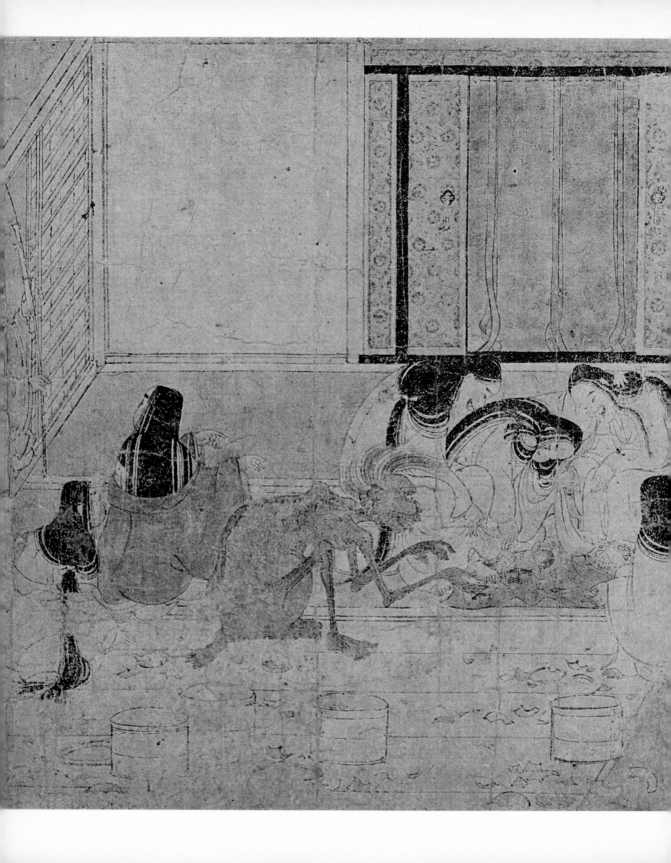

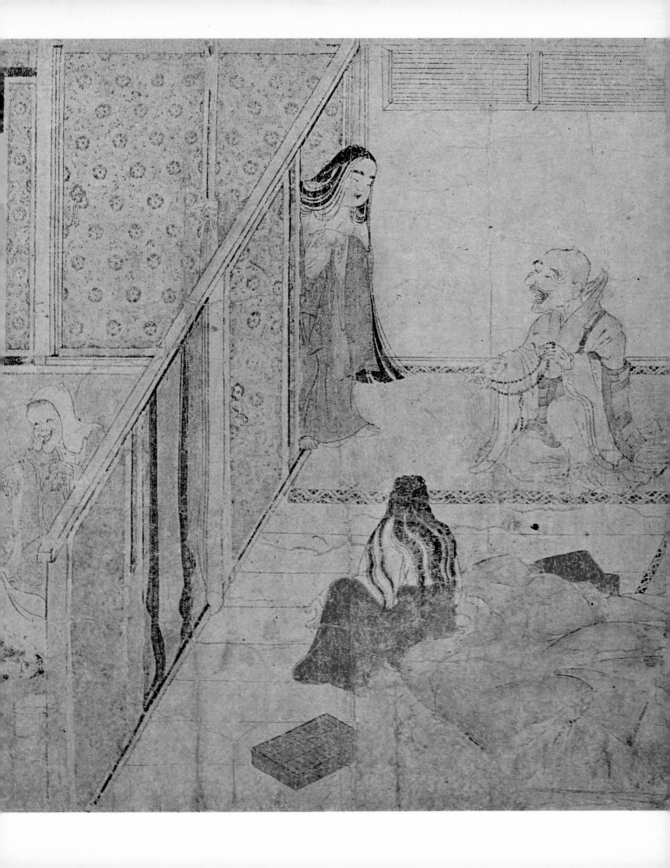

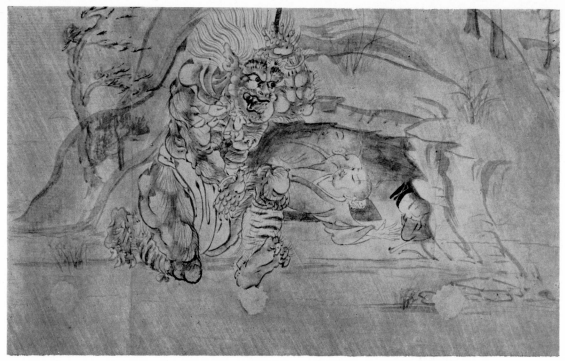

36. Kegon-shū Soshi Eden. *Kamakura period, 13th century. Kōzan-ji, Kyoto.*

Use of Color

Part of the charm of *emaki* lies in yet another major distinguishing characteristic, the use of color and the use of black lines alone. Within these two broad categories, each of which contains handscrolls done in *onna-e* and *otoko-e* styles, there are, of course, works that combine elements of both and so elude firm characterization. In general, however, we may also typify *emaki* as either polychrome or monochrome.

• POLYCHROME EMAKI. All the scroll paintings in this group make use of color, but a careful examination reveals that some polychrome works stress color almost exclusively, others stress brush lines, and still others treat both with equal emphasis.

The *emaki* that emphasize color, such as the *Genji*

scroll painting, are characterized by a technique known as *tsukuri-e*—literally, "made-up picture" or "manufactured painting." The preliminary drawing was executed in black ink with a fine brush. Heavy, opaque pigments were then carefully and systematically applied or built up over a white lead base until all empty space on the paper was covered. The original brush lines, now concealed by paint, were carefully inked in again as outlines.

Some of the thick layers of pigment on the *Genji* scroll have worn away, revealing notes jotted down on the original paper indicating what was to be depicted and what colors were to be used. This confirms scholars' assumptions that a master painter must have laid out the overall design with instructions to show his assistants where and what to paint. Certain "specialists" in crests and other details probably put on the

時羅刹女捨己身相而化作王阿重夫人之所
在王後行語於王言我當為王寂阿而愛
重何以棄我夜行至此更愛誰耶
婦女羅刹變作王夫人之所

37. Jūni Innen Emaki (*Scroll of the Twelve Fates*). Religious. Kamakura period, 13th century. Nezu Art Museum, Tokyo.

finishing touches. It also appears that the composition was sometimes changed while the pigments were being built up.

Color is, of course, paramount in *emaki* created by the *tsukuri-e* method. The final work emphasizes the blending and the sharpness of the colors; the fine, unaccented outlines are never conspicuous. They are used simply to border the flat, painted planes and do not stand out by variation in thickness or intensity of ink. Instead, the heavily and elegantly painted colors create the total effect. The *tsukuri-e* technique was used not only for the *Genji* scrolls but also for the *Nezame Monogatari Emaki*, the *Murasaki Shikibu Nikki Emaki*, and other scroll paintings based on works of literature; all these *emaki* were created in the *onna-e* style.

A representative polychrome *emaki* that emphasizes line rather than color is the *Shigi-san Engi*. In contrast to the *Genji* scrolls, the *Shigi-san* scrolls emphasize line drawing, for which thin color washes clarify linear effects. Other *emaki* that belong to this group include the *Gaki Zōshi* (Scroll of Hungry Ghosts), the *Jigoku Zōshi* (Scroll of Hell), and the *Yamai no Sōshi;* all of them are *otoko-e,* lively narratives full of characters from all social classes.

In contrast to the *Genji* and the *Shigi-san emaki,* both of which may be easily categorized, a great many handscrolls emphasize color and line equally. This synthetic style became popular and was carried to sophisticated heights in the early Kamakura period (late twelfth to mid-thirteenth centuries). The *Ban Dainagon Ekotoba,* the *Heiji Monogatari Emaki,* and the *Kegon-shū Soshi Eden* (Biographies of the Patriarchs of the Kegon Sect) are outstanding works in this group of scroll paintings.

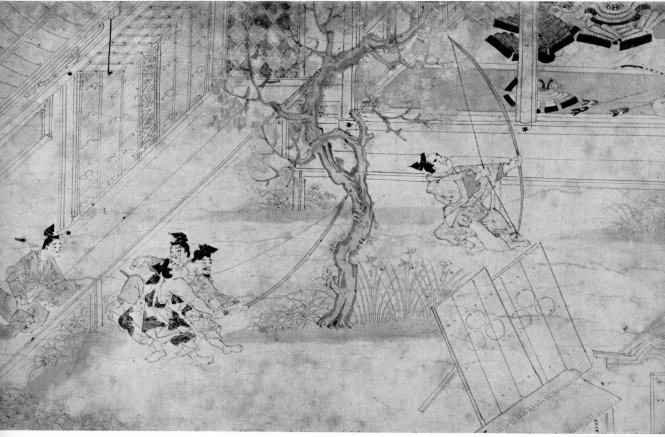

38. Obusuma Saburō Ekotoba. *Kamakura period, 13th century. Asano Collection, Tokyo.*

• MONOCHROME EMAKI. The *hakubyō* or "white pictures" (also called *shira-e*) are *emaki* drawn almost exclusively in black ink. Except for slight dots of red on the lips of individuals, and sometimes *shōboku* (a brownish-tinged black ink) on hair, headdresses, and furnishings, there is no color. Masterpieces of the monochrome *emaki* include the *Chōjū Jimbutsu Giga*, the *Makura no Sōshi Emaki*, the *Takafusa-kyō Tsuyakotoba Emaki* (Love Letters of Lord Takafusa, Plates 76, 77), and the *Zuijin Teiki Emaki*.

The *Chōjū Jimbutsu Giga* is an ink drawing characterized by various shades of black ranging from jet to light gray, with lines that exhibit dynamic variations in thickness. By means of the rapidly drawn lines, the artist has created a simple yet eminently successful drawing. Line in this scroll painting does not carry the somewhat negative connotation of border or outline; rather, it is the basis for the lively and dynamic composition.

The *Makura no Sōshi Emaki,* a scroll painting in the courtly tradition, is characterized by precise, sharp, firm lines; line is the dominant compositional element and the black ink controls the picture plane strongly and definitively. We see no casual, sketchy effect here. Hard and brilliant, this work has much in the way of visual interest; the use of lines and the variation in ink tones from pale, diluted black to jet black combine to make it a fascinating, almost abstract composition. It is unexcelled in its presentation of decorative detail such as screens, lattice doors, and other architectural elements; and the manner in which the court ladies' flowing hair is painted in jet black, their eyebrows

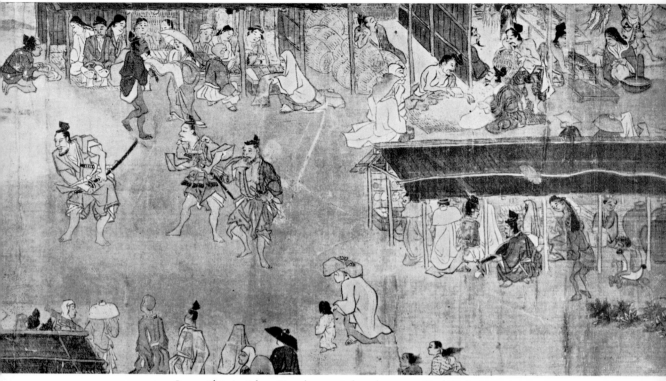

39. Ippen Shōnin Eden. *Kamakura period, 13th century. Kankikō-ji, Kyoto.*

40. Ippen Shōnin Eden. *Kamakura period, 13th century. Kankikō-ji, Kyoto.*

41. *Kibi Daijin Nittō Ekotoba. Kamakura period, 13th century. Museum of Fine Arts, Boston.*

blurred, and a small amount of red applied to their lips heightens the visual effect. The *Makura no Sōshi* recreates the Heian court world in black and white, just as the *Genji* scroll painting does in color.

Although the lines of the *Zuijin Teiki* are of consistent thickness, this work possesses the spirited force and fluency of the *Chōjū Jimbutsu Giga*. The facial expressions of its characters are full of individuality, and it is charged with a feeling of freedom and liveliness. One characteristic that distinguishes this scroll from the *Chōjū* and *Makura* scroll paintings is that the faces of the characters as well as the trappings of the horses are faintly colored.

Perspective

The perspective found in Western painting is un-

known in *emaki* art. This is partly the result of the limited width of the *emaki* format: geometrical accuracy, if enforced, would have severely inhibited the artist in his depiction of characters and the narrative. Although *emaki* artists exploited the potential of the horizontal handscroll to the fullest, they always faced certain limits in terms of organization of space. Their solutions to these problems of compositional arrangement, however, are unique and effective.

One method, used especially to portray the intimate lives of the aristocrats, is termed *fukinuki-yatai,* or "blown-away roofs." Because the *emaki* format is limited in width, it was necessary to employ a diagonal, downward-looking perspective in order to show a number of people and objects in the same scene. Roofs and ceilings, as well as some room partitions, were then radically dispensed with in portrayals of interior

court scenes so that the viewer could enter directly into the intimate personal relationships that are their focus. Although this device is a nonrealistic abstraction, it nevertheless heightens the viewer's dramatic perception and involvement with what is being depicted (Plates 7, 71).

The technique of slanting lines (shasenbyō, literally "oblique line depiction") is used in emaki of court origin and inspiration: roofs, verandas, and walls are drawn with parallel diagonal lines, a technique that uses to the fullest advantage the limited depth of the format. Most of the slanted lines are drawn from the upper right to the lower left, carrying the eyes of the viewer in the right to left order in which the scroll is unrolled (Plates 70, 73).

The emaki artist sometimes seems to suggest or stress the emotion inherent in a scene by reordering these slanted lines to create a disturbing visual effect. Scenes characterized by nearly vertical lines that are charged with a sense of drama and tragedy include the "Kashiwagi" (Plate 7) and "Law" (Plate 2) scenes from The Tale of Genji, both depictions of moments of sorrowful reflection. Slanted lines drawn in reverse, from upper left to lower right, as in Plate 11, may also suggest the unease underlying a certain scene. However, the relationship between the intensity and direction of the slanted lines and the emotional content of a scene has yet to be systematically proved.

Scale

A departure from the Western tradition appears in terms of scale as well as in perspective. For example, emaki heroes are often portrayed in closeup views as

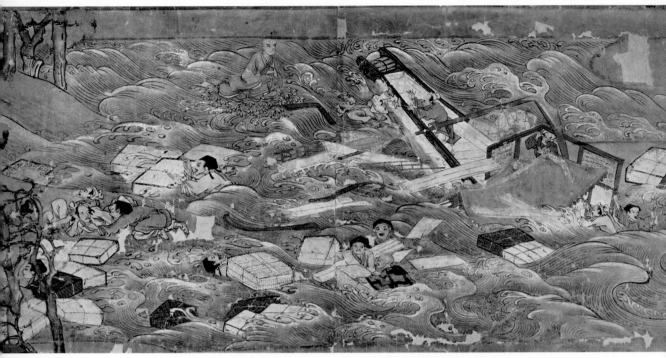

42. Tōsei Eden. *Kamakura period, 13th century. Tōshōdai-ji, Nara.*

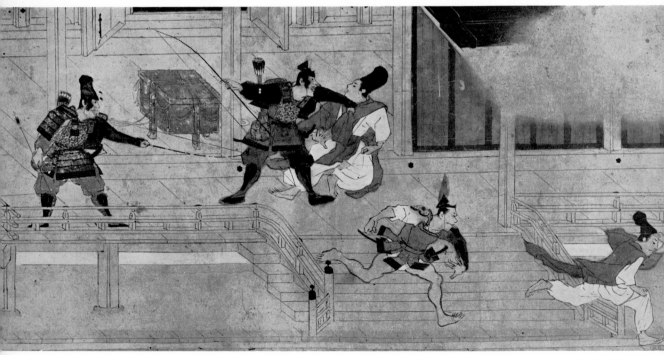

43. Heiji Monogatari Emaki. *Kamakura period, 13th century. Tokyo National Museum.*

44. Shōgun-zuka Emaki (Tomb of the Shōgun). Narrative. Kamakura period, 13th century. Kōzan-ji, Kyoto.

disproportionately large in size in relation to their sur-roundings. A scene from the *Kitano Tenjin Engi* (Plate 64) shows Sugawara Michizane in exile in Tsukushi, standing on top of Mount Tempai appealing to the gods to affirm his innocence and to vindicate him. The artist painted the hero as a virtual giant in order to stress his determination and strength of character. A scene from the *Eshi no Sōshi* (Plate 91) depicts the painter couple as larger than the other characters to draw attention to them and to stress their disappoint-ment over the fact that Iyo Province, the land be-stowed on them, was already occupied by somebody else. A section from the third scroll of the *Shigi-san Engi* (Plate 17) shows a nun and her attendant on their way to Nara in search of the nun's brother; they

are drawn much larger than they should be from the standpoint of realistic scale.

Occasionally, too, plants are depicted as extraor-dinarily large, especially in comparison with human beings (Plate 117). A scene from the *Ise Shin Meisho Uta-awase Emaki* (Plate 115) shows disproportionately large bush clover, pampas grass, goldenrod, and a ma-ple tree in the garden of a house in which a woman is fulling cloth. The unrealistic size of these plants at-tracts attention and effectively communicates the at-mosphere of autumn. A section from the *Matsuzaki Tenjin Engi* (Legends of Matsuzaki Tenjin Shrine, Plate 118) shows Sugawara Michizane, destined to exile at Dazaifu, bidding farewell to his beloved plum tree. The tree assumes a prominent role in the com-

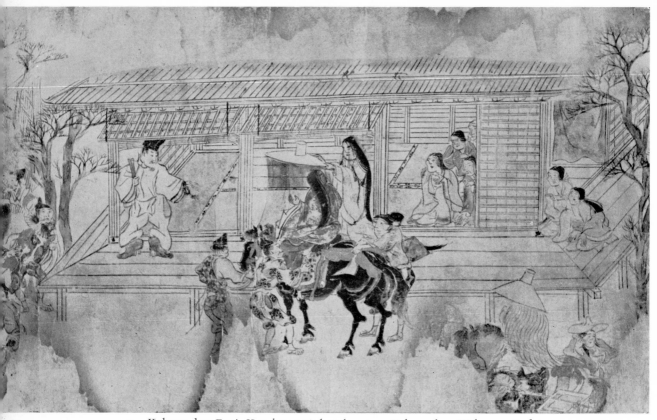

45. Kokawa-dera Engi. *Kamakura period, 13th century. Kokawa-dera, Wakayama Prefecture.*

position; it is much larger than the man looking at it from the Plum Palace. The large, colorful plum blossoms not only evoke our admiration for their beauty, but also make Michizane, the hero, seem dramatically small and pitiful.

Narrative Techniques

• MONOSCENIC. Although *emaki* are often called "picture scrolls" in the West, almost all scroll paintings contain both pictures and text, associated in various ways. The close relationship between illustration and accompanying calligraphic text is an important feature of *emaki* art, one that reflects the intimate connection between writing and painting that has always existed in East Asia. (There are, however, a few *emaki*

containing no textual portions at all; the *Chōjū Jimbutsu Giga* is one of these exceptions.)

In monoscenic *emaki,* a section of text is followed by a single scene. The alternation of text and picture is repeated to develop a story or a theme; pictures illustrate the text, which in turn sets the scene and explains what cannot be illustrated. In a scroll painting of this kind, the number of pictorial portions should be equivalent to the number of textual portions; an *emaki* in which textual and pictorial sections do not correspond is incomplete. One example of a monoscenic scroll painting is the *Genji* handscroll; another is the *Murasaki Shikibu Nikki Emaki.*

• CONTINUOUS NARRATION. *Emaki* characterized by continuous narration, in which one scene flows into

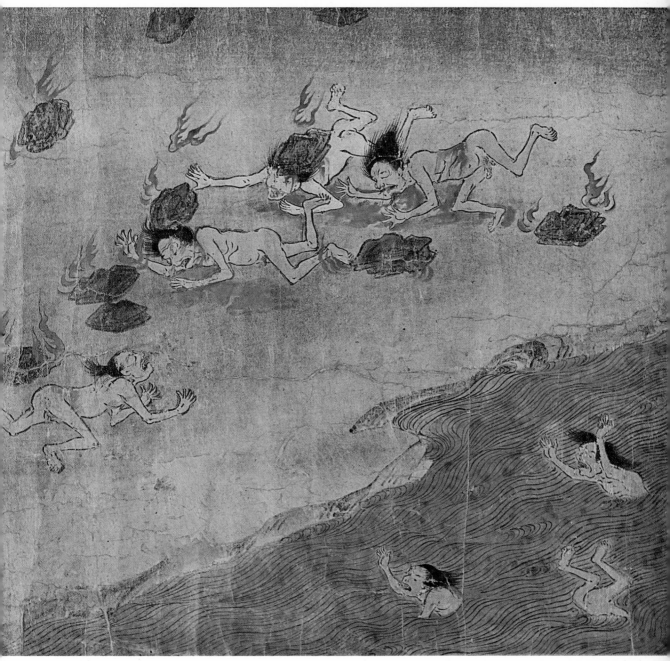

46. Jigoku Zōshi. Sōshi *usually consist of a collection of tales tied together by a common theme. The eight principal hells described in various Buddhist sutras are the subject of this vivid scroll painting. In this scene from the hell of fire, flame, and stones, people are seen suffering for crimes they committed during their previous existences on earth. Such religious scrolls were inspired by the growing belief in troubled late Heian and early Kamakura times that the period of Mappō, "the end of the Buddhist law," had come. Buddhist sects, offering release from suffering through rebirth in Paradise, often focused on the horrors of hell to encourage piety in their devotees. Kamakura period, 12th century. Tokyo National Museum.*

47. Zuijin Teiki Emaki. *Kamakura period, 13th century. Okura Museum, Tokyo.*

another, generally contain portions of text as well. These sections are usually found at the beginning of each scroll and are often interspersed within the narrative at various points and at the end of a roll. The first scrolls of both the *Shigi-san Engi* (Plates 14, 16) and the *Ban Dainagon Ekotoba* (Plate 33), which are two superb examples of continuous narrative *emaki,* lack sections of text. These scrolls must originally have had textual portions that are now lost. Fortunately, however, the *Ban Dainagon* illustrates a well-known historical event and the later *Shigi-san* scrolls match in content a piece of thirteenth-century literature, so we are able to make a complete and accurate interpretation of both works. Continuous narrative techniques, which are characteristic of *otoko-e,* probably developed

as an artistic response to stories and legends that placed greater emphasis on the unfolding of plot; earlier court literature had de-emphasized quick-moving narrative in favor of exploring the psychological complexities of human emotions and relationships.

An *emaki* of the continuous narrative type often involves the viewer with nature and with the men depicted in these natural settings. For example, as soon as the viewer unrolls a chapter of "The Burning of Otemmon Gate" in the *Ban Dainagon Ekotoba emaki* (Plate 33), he finds himself among a multitude thrilled and horrified by the great fire. As he unrolls the scroll, he becomes one of those hurrying to the scene of excitement. When the burning gate appears before him, he feels as if he is actually standing, awestruck, in front

48. Kuge Retsuei Zukan. *Kamakura period, 13th century. Kyoto National Museum.*

of the conflagration, participating in the activity.

Text and pictures are associated in yet other ways. Sometimes descriptions of events are written in small oblong areas and inserted above a scene (Plates 22, 23). In some *otogi zōshi,* conversations are written directly on the scrolls, eliminating the necessity for separate textual portions (Plates 93, 101, 108, 110). And in the *E Inga-kyō* (Plate 1), the entire bottom portion of the horizontal format is reserved for a transcription of the sutra; illustrations run along the upper portion of the scroll.

• REPETITION. Various sorts of repetitive techniques are used to develop a story and to keep the identity and the actions of the hero or main characters clear to the

viewer. The most common method is to show the main figure again and again in front of a changing background—a technique that works particularly well with the *emaki* format, in which scenes can be smoothly and continuously changed. A fine example of *hampuku-byōsha* ("repetition picture") is the first scroll of the *Shigi-san Engi;* here the main characters are repeatedly depicted in a continuously moving sequence of scenes.

Iji-dōzu ("different time, same illustration") is another repetitive technique used to illustrate a sequence of events. Here the different actions of a person at varying times are shown in sequence in front of a static background. Examples of this technique are found in the *Shigi-san Engi* (Plate 13) and in the *Ban Dainagon*

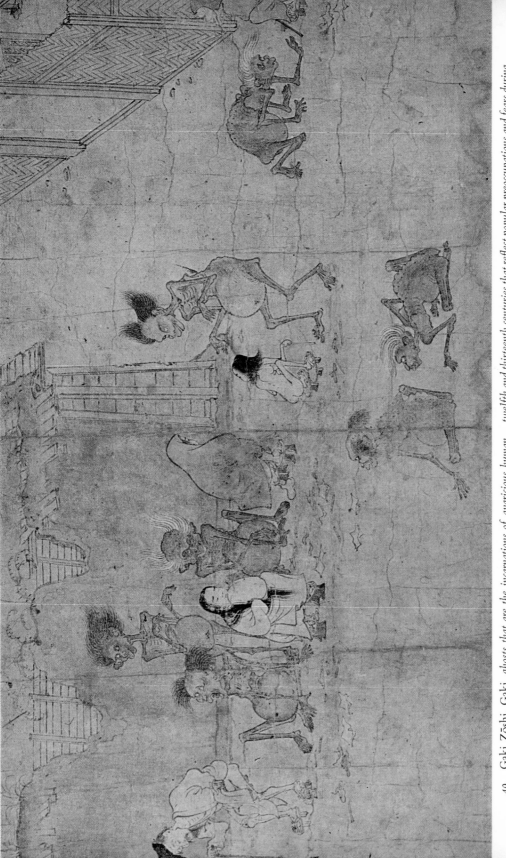

49. Gaki Zōshi. Gaki, ghosts that are the incarnations of avaricious human beings, are doomed to hunger and thirst and are known to crave excrement. Here they gather expectantly around men and women defecating at a filthy street corner. This emaki is one of the many religious scroll paintings produced during the twelfth and thirteenth centuries that reflect popular preoccupations and fears during a turbulent period of natural disasters and political disorder. Hungry ghosts inhabit one of the six Buddhist realms of rebirth. Kamakura period, 12th century. Tokyo National Museum.

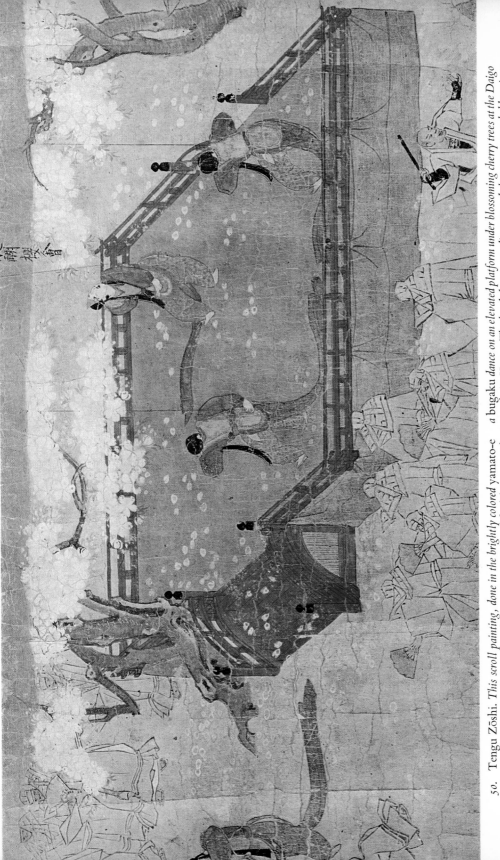

50. Tengu Zōshi. This scroll painting, done in the brightly colored yamato-e style, satirizes the conceited priests of seven great temples of feudal Japan. Although they are not visible in this scene, the priests are portrayed as tengu, long-nosed goblins that are the symbol of braggarts. In this scene, dancers are performing a bugaku dance on an elevated platform under blossoming cherry trees at the Daigo temple in Kyoto. The hooded men standing around the stage are probably priests from this and other temples. Kamakura period, 13th century. Tokyo National Museum.

51. *Facial expressions: left to right*, Shigi-san Engi, Genji Monogatari Emaki, Makura no Sōshi Emaki.

Ekotoba (Plate 21). The scene in the *Shigi-san* hand-scroll depicts, from right to left, the nun's activities from evening to dawn before the image of the Great Buddha at Tōdai-ji in Nara: she is seen praying, then napping, then offering a thanksgiving prayer after awakening from a dream in which the Buddha has informed her of her brother's whereabouts; finally, she is seen leaving the Hall of the Great Buddha.

The portion of the *Ban Dainagon* scroll shown in Plate 21 depicts the actions of a father and his son, who are seen moving in a clockwise direction in a semi-circular space: the father runs into a fight between his son and another boy, grabs his son by the arm, and kicks away the other boy (who is not shown in this illustration). Both examples depict a sequence of events taking place in one scene, but the first covers a period of many hours, whereas the latter illustrates an episode that took place in a matter of seconds.

Expressive Techniques

Emaki artists utilized a variety of expressive techniques to delineate character, emotion, and atmosphere, many of them unique to *yamato-e* painting and indicative of Japanese social and cultural attitudes toward their world and its people.

• CHARACTERIZATION. At first glance, most of the aristocrats in *onna-e emaki* look as though they are asleep. Portrayed in simplified and idealized form in the *hikime-kagihana* ("slit eyes and hook-line nose") convention, each impassive, stylized face, with its slitlike eyes,

hook-line nose, straight eyebrows, red-dotted lips, and plump cheeks, seems to conceal all emotion (Plates 6, 51, 77). Although devoid of strong emotional and physical characteristics, these faces can have the same deep effect on the viewer as Nō masks, which suggest human feelings only by allusion and association.

As in the Nō drama, subtle changes in expression and posture—perhaps a slight variation in the tilt of a head—express grief, anguish, or other strong emotion. Holding a sleeve to one's face, for instance, indicates weeping and sorrow (Plates 2, 75, 105). For the most part, however, the viewer must use his knowledge of the events portrayed and his sensitive imagination to respond to the drama inherent in each scene.

There is a sense of static beauty in the portrayal of these aristocrats, whose figures are hidden under thick layers of garments and whose faces and movements reflect almost superhuman control of the often turbulent emotions that seemed to govern their lives. Almost all the court ladies, for example, are shown sitting; this posture is symbolic of entire lives lived within the dimly lit interiors of various palatial residences, dependent on the generosity and attention of men who were free to go elsewhere within Heian polygamous society.

The people in scrolls such as the *Shigi-san Engi,* by contrast, seem to be in continuous motion. Their facial expressions, which are vividly emphasized, depicted in an almost caricaturelike fashion, show a wide range of feelings. Such concern with human emotions and "realistic" portraiture was an element in *emaki* art that indicated the emergence of new cultural trends de-

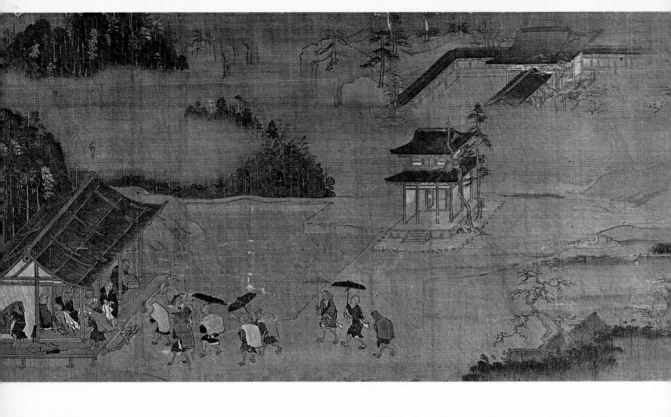

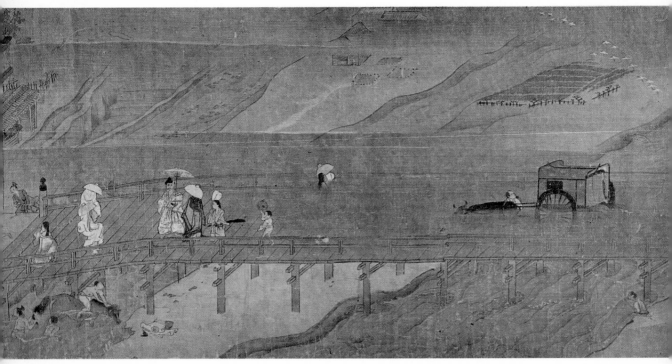

◁ 52. Ippen Shōnin Eden. *Scroll V. Here Ippen and his party are caught in a shower and seek shelter in the temple grounds of Ono-dera in Shimotsuke Province, north of present-day Tokyo. Some members of the group have already reached a hut and are seen removing their wet clothing and drying themselves. The tall, dark trees in the distance contribute to the solemn atmosphere of this scene, as do the faint diagonal lines representing the soft rainfall. Here, as in most* emaki, *nature is not independent subject matter but rather a background element for man and his activities. Kamakura period, 13th century. Kankikō-ji, Kyoto.*

◁ 53. *(below)* Ippen Shōnin Eden. *Scroll VII. This scroll painting, a National Treasure, is noted for its finely executed scenes of nature. Ippen, the itinerant monk who founded the Jishū (Timely) sect, is seen here crossing a bridge over the Kamo River in Kyoto. He wears a straw hat and black robe, and an attendant carries a parasol to protect him from the sun, while a young boy fans him from behind. Although the landscape seems to engulf the figures, in the Chinese fashion, its treatment is definitely within the* yamato-e *style. Men are bathing a horse in the river, while on the right bank a boy is fishing. The restrained use of colors and the mist covering portions of the landscape create a soft and gentle atmosphere. Kamakura period, 13th century. Tokyo National Museum.*

veloping at the end of the Heian and the beginning of the Kamakura periods. Whereas artists were constrained by the facial and figural conventions for portraying aristocrats, they were allowed to characterize commoners more freely and imaginatively. In part this was a result of the belief that only the nobility possessed the education and breeding necessary to be able to conceal their emotions; but in part the interest in more individualized faces was also a result of the development from the mid-twelfth century on of a type of realistic portraiture called *nise-e* or "likeness picture."

• THE ROLE OF NATURE. The world of nature plays an important role in *emaki* art. Scrolls depict animals and plants, the time of day, and landscapes in all seasons. But nature in *emaki* is not inimical to man: mountains slope gradually; the waves of oceans and rivers rock gently; groves and fields lie intimate and inviting; rain and snow are sketched in a soft and friendly spirit (Plates 52, 67). The way natural elements are depicted in *emaki* reflects the mild climate and gentle landscape of Japan; the natural inspiration is molded and heightened by the decorative and personalized *yamato-e* style. There are, of course, some exceptions; in the *Kitano Tenjin Engi* (Plate 78) we see Son'i, the head priest of Mount Hiei, cutting through the flooded Kamo River aided by the miraculous power of the Buddha. This scene is charged with a sense of drama and urgency, and the waves roll threateningly around the priest's oxcart.

Gracefully painted animals and plants generally serve to indicate the seasons, particularly spring and fall, and to set the emotional tone for a scene. Geese

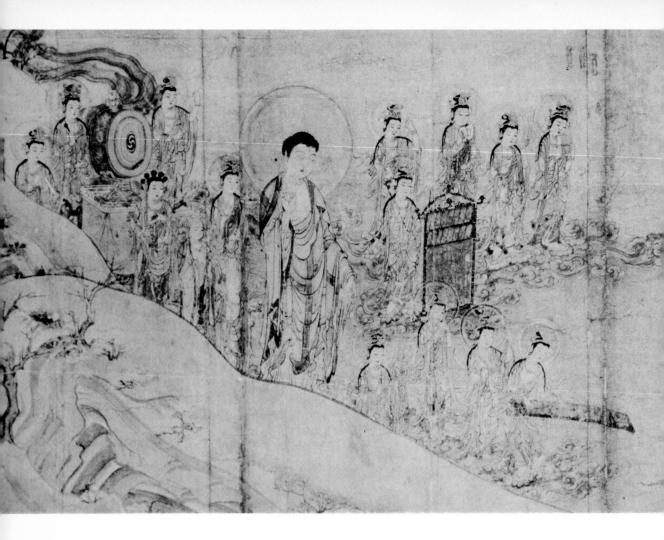

and heron flying in flocks are symbols of the advent of spring and autumn; plum and cherry blossoms suggest the peace and freshness of spring; chrysanthemums, bush clover, pampas grass, and maples mark lonely autumn scenes.

A scene from the *Genji* scroll (Plate 2) depicts Prince Genji's farewell visit to his dying consort Murasaki no Ue. It is an autumn evening; bush clover, pampas grass, bell flowers, and goldenrod sway just beyond the veranda in a strong and restless wind. These plants are painted larger than life, and the farewell poems that Genji and Murasaki exchange relate directly to them: the poems compare the short-lived dew on the grass to the transience of life.

In contrast to Chinese landscape scrolls, nature is treated not as independent subject matter, but rather as a background element for man and his activities. Nature exists in the *emaki* as an integral part of man's life, as a beloved friend, and there is often a strong association of human emotions with the world of nature. Scroll paintings famous for their evocative recreation of the world of nature include the *Saigyō Monogatari Emaki* (Plates 29–30) and the *Ippen Shōnin Eden* (Plates 40, 52, 53).

Interesting techniques are used to underscore the relationship between nature and man. One of these is mist. Mist often suggests spring and the hope and joy that man usually feels at this season. Mist is also used as a means of shifting from one scene into another. When continuous narrative techniques are employed instead of monoscenic composition and scenes must be changed gracefully, mist is added to end one scene

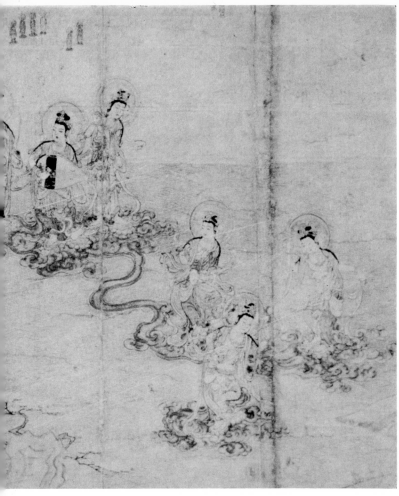

54. Taima Mandara Engi. *Kamakura period, 13th century. Kōmyō-ji, Kanagawa Prefecture.*

(overleaf)
55. Sungyū Ekotoba *(Scroll of the Fine Ox).* ▷
Documentary. Kamakura period, 13th century. Fujita Art Museum, Osaka.

and begin another (Plate 18). Bands or layers of mist can also signify the passage of time, and in a summer night scene in the *Kasuga Gongen Reigen Ki* (Plate 89), horizontal black bands of mist at the top of the picture frame the scene and make the human activity more conspicuous. In late *emaki,* however, particularly those from the Muromachi period, bands and clouds of mist serve merely decorative purposes, and they are depicted in a rigid and highly stylized manner (Plates 102, 119, 120).

Viewing Emaki

The *emaki* is a long horizontal scroll that is viewed section by section, in contrast to the *kakemono* or vertical hanging scroll, which presents a single, complete composition. The viewer lays the *emaki* on a table or on the floor and successively unrolls and rolls up the scroll, moving from right to left in the same manner that Japanese writing is read. In order to create an *emaki,* up to several dozen sheets of paper (and occasionally silk) are joined together. A cover is then attached to one end of the roll, and a roller to the other.

The existing *emaki* vary in size. The *Genji* scroll, for instance, measures 21.8 cm in width, whereas the Jōkyū version of the *Kitano Tenjin Engi* measures 52 cm (the greatest vertical measurement found in an *emaki*). Most scrolls measure from about 30 cm to between 36 and 39 cm in width; the horizontal measurement usually ranges from 9 to 12 m. It is this exceptional form that is one of the most salient characteristics of *emaki* art. The longest scroll painting was the *Kibi*

Daijin Nittō Ekotoba, which measured 24.4 m until it was cut up into four scrolls a few years ago. Most *emaki* comprise one to three scrolls, although some, such as the *Hōnen Shōnin Eden* (Biography of the Monk Hōnen), with forty-eight individual scrolls, have many more. If all its scrolls were added together, the *Hōnen emaki* would be 520 m long, the longest scroll painting in existence.

Some *emaki* comprising many scrolls have come down intact. These complete *emaki* are usually those with religious themes (for example, the origins of temples and shrines and the biographies of religious leaders), and their fine state of preservation probably results from the fact that they were cared for as sacred treasures in the temples and shrines to which they be-

longed. The secular *emaki,* on the other hand, must have been transferred from one collection to another. A set was probably often divided among different people. Religious *emaki* such as the *Hōnen Shōnin Eden* (forty-eight scrolls) and the *Kasuga Gongen Reigen Ki* (twenty scrolls) were kept in the Chion-in in Kyoto and the Kasuga Shrine in Nara, respectively, and both are complete. The *Genji, Murasaki,* and *Heiji emaki,* on the other hand, survive only in fragments, and those scrolls that do exist are owned by different collectors.

The *emaki,* with its unique format, requires a special method of viewing. There is always a certain distance between other forms of art—the hanging scroll, the folding screen, the sliding door—and the viewer, and one always sees these other works in their entirety.

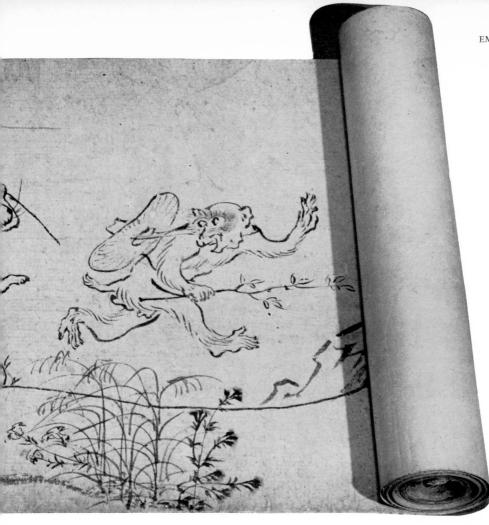

56. Chōjū Jimbutsu Giga. Heian period, 12th century. Kōzan-ji, Kyoto.

In the case of the *emaki,* however, the viewer sees only the portion of the scroll unrolled between his hands, which usually measures approximately 60 cm (Plate 56).

The most important thing to remember is that in *emaki* viewing, the viewer changes the scenes himself at his own speed. This movement in time and space distinguishes *emaki* art, which may well be compared to the cinema of today. Like motion pictures, a majority of *emaki* are devoted to stories and narrative accounts, to human tragedies and comedies. Scenes appear and disappear one after another. If a new scene is as calm and static as those in the *Genji* handscroll (Plates 6, 9), the viewer may stop for a while to appreciate the lyrical atmosphere. If a panorama of excit-

ing scenes unfolds, as in the "Flying Granary" portion of the *Shigi-san Engi* (Plates 14, 16), he may move his hands more quickly as he becomes involved in the story and is eager to learn the outcome.

Again, unlike other forms of art, an *emaki* ideally should be handled by only one person at a time. Looking at *emaki* partially unrolled in glass cases, as they usually are displayed in museums, denies the viewer the opportunity to watch the complete panorama moving and changing slowly and steadily before his eyes. Fortunately, *emaki* can be appreciated in other ways; facsimiles are available at some libraries and universities, and may be viewed in the traditional manner. And if the viewer would like simply to enjoy an *emaki* and not use it for research purposes, the selected

57. *Rolled picture scroll showing an elaborately patterned silk cover, tied by woven string. An* emaki *is made up of several dozen sheets of paper or silk joined together, with a cover attached to one end of the sheets and a roller to the other.*

portions available for inspection in museums should be sufficient to give him an understanding of the characteristics of a particular work.

In scroll paintings like the *Ippen Shōnin Eden* (Plates 52, 53) and the *Saigyō Monogatari Emaki* (Plates 29–30), in which the main characters travel throughout the country, the viewer can vicariously become an itinerant monk himself; he is involved with the group of pilgrims and appreciates the continually changing landscapes through which he wanders. This interplay between the work and the viewer, in which the latter becomes involved in the way of life depicted and in the natural settings that provide the background, is one of the joys of the *emaki* art form.

3

Emaki as Historical Mirrors

Because *emaki* are one major form of painting from the Heian, Kamakura, and Muromachi periods, they prove invaluable in studying the lives and customs of medieval Japanese. All manner of people from all walks of life are portrayed going about their daily tasks and experiencing the emotional complexities of life. Nearly all the stories depicted in the scroll paintings take place in Japan, although a few are staged in China, Korea, Central Asia, and India.

One important fact to bear in mind when considering *emaki* as social historical documents, however, is that they usually depict people and structures as they looked at the date of the production of the *emaki,* even when the narratives deal with people and events of several centuries earlier. For example, the Ishiyamadera temple was built during the Nara period, but the construction scene that appears in the *Ishiyama-dera Engi* (Legends of Ishiyama-dera, Plate 74), depicts the event as it would have looked had it taken place during the Kamakura period.

Literally thousands of people come to life on the extant *emaki* scrolls. The majority are Japanese, and although there are many historical personages portrayed, others are creations of the painters' imaginations or characters from fiction. Commoners—farmers, fishermen, craftsmen, and entertainers—appear in *emaki* dealing with legends of temples and shrines, popular narratives, and folk tales, but are seldom represented in the scrolls that illustrate literary works of court origin, such as *The Tale of Genji,* or in war chronicles like the *Mōko Shūrai Ekotoba.*

Even in the scrolls in which they do appear, lower-

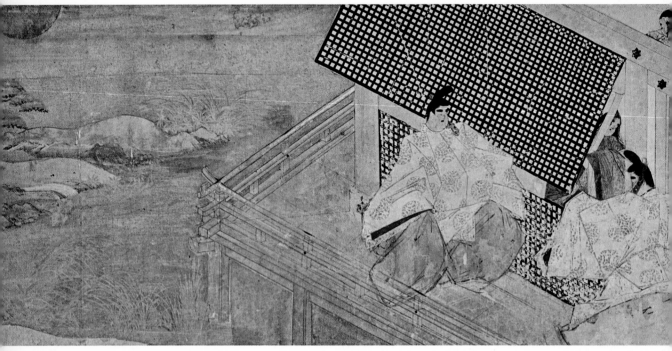

58. Murasaki Shikibu Nikki Emaki. *The diary of Murasaki Shikibu, the author of* The Tale of Genji, *inspired this emaki, done in the elegant* tsukuri-e *technique using opaque colors built up in layers. This scene takes place on an autumn evening in 1008 after the visit of Emperor Ichijō to the mansion of Fujiwara Michinaga. Lady Murasaki is in her room on the eastern side of the corridor when two courtiers approach and tease her to open her lattice door. Murasaki is shown in the inner part of the room, at the upper right. The use of diagonal lines in spatial perspective is apparent in this scene, and the black and white grillwork of the lattice door provides an effective, almost abstract backdrop for the gentlemen in their magnificent court garb. Kamakura period, 13th century. Gotō Art Museum, Tokyo.*

class people are usually not the leading characters; these roles are largely the prerogative of aristocrats, warriors, and priests. Nevertheless, genre scenes of ordinary people add a great deal of interest and charm to scroll paintings. For example, some of the most appealing sections of the *Shigi-san Engi* occur in the third scroll, which follows an old nun searching for her brother: women draw water from a well and wash clothes (Plate 15) and a mother nurses her baby while an elderly man and woman chat with the nun by the roadside (Plate 19).

Some scroll paintings do portray commoners as heroes—for example, the *Tōhoku-in Shokunin Uta-awase Emaki* (Plate 69) and the *Sanjūni-ban Shokunin Uta-awase Emaki* (Poetry Contest in Thirty-two Rounds by Members of Various Professions, Plate 98). These

emaki depict individual craftsmen and tradesmen at work, and each portrait is accompanied by a *waka* poem. This type of scroll painting may have been created to chronicle the various new trades and crafts that developed as the economy grew in complexity during the late Kamakura and Muromachi periods.

Emaki are therefore an extremely useful source for a study of the different trades and crafts of medieval Japan. The sixteenth-century *Shichijūichi-ban Shokunin Uta-awase Emaki* (Poetry Contest in Seventy-one Rounds by Members of Various Professions), for example, depicts 142 craftsmen, among them sword-sharpeners, sakè brewers, horse dealers, wizards, fishmongers, dice makers, armorers, bamboo-blind makers, doctors, astrologers, and sumo wrestlers. The attitudes and dress of the various characters depicted in

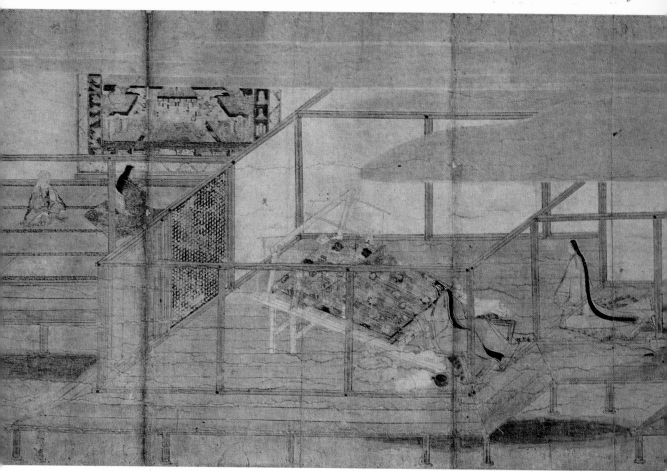

59. Taima Mandara Engi. *According to legend, the Taima mandala, which depicts scenes of the Western Paradise, was woven from thread spun out of lotus stems by a nun who was the incarnation of Amida. Another nun, an incarnation of Kannon, wove the man-dala. It came to be made because a princess, daughter of a court dignitary of the Nara period and a fervent believer in Amida Buddha, confined herself in the Taima temple and prayed that she might see a vision of the living Amida. She realized that her prayer had been answered when the nun who had spun the thread for the mandala explained its contents and then revealed herself to the princess as Amida before leaving for the Western Paradise. When the princess died more than a decade later, she was reborn in the paradise of which she had always dreamed. In this scene, from right to left, Kannon is seen walking toward the loom, then sitting and working at it. In the next room, some time later, the completed mandala is displayed on the wall while Amida, appearing as a nun, explains its significance to the young princess. The use of* fukinuki-yatai *allows the viewer to see into the interior scenes and to follow the sequence of the plot. Kamakura period, 13th century. Kōmyō-ji, Kanagawa Prefecture.*

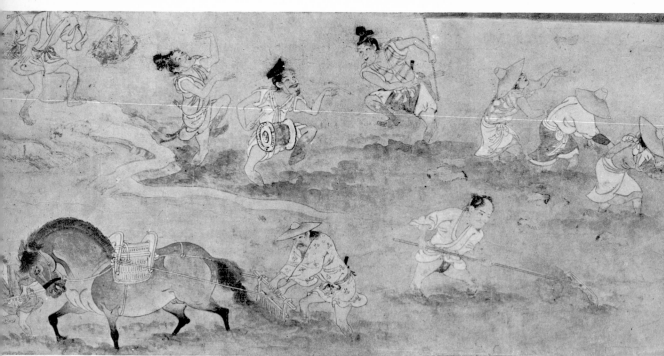

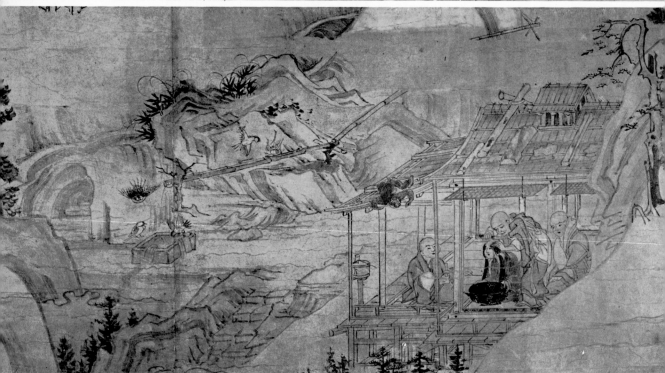

60–61. Hōnen Shōnin Eden. *Kamakura period, 14th century. Chion-in, Kyoto; Zōjō-ji, Tokyo.*

62. Sagoromo Monogatari Emaki. *Kamakura period, 14th century. Tokyo National Museum.*

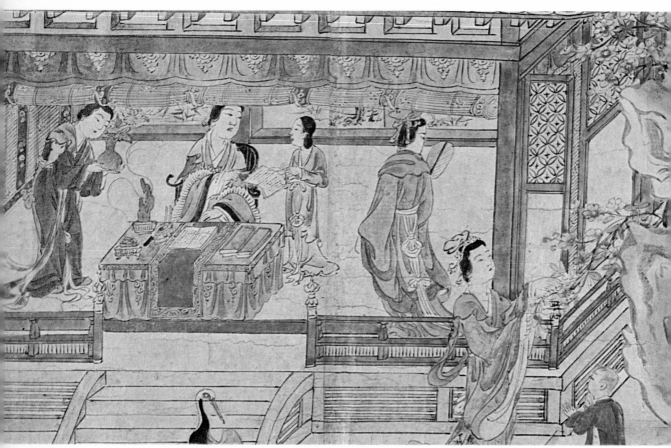

63. Kegon-shū Soshi Eden. *The romantic legend of the founders of the Kegon sect has remained a popular subject for artists throughout the centuries. The Korean monk Gishō (Ui Sang) went to China in the seventh century for Buddhist training and there a Chinese girl, Zemmyō (Shan-miao), fell in love with him. Here Zemmyō is seen confessing her love to Gishō, who urges her to transform it into spiritual affection. Gishō eventually returns to his country by boat, and the faithful Zemmyō, who arrives at the harbor just after his de-*

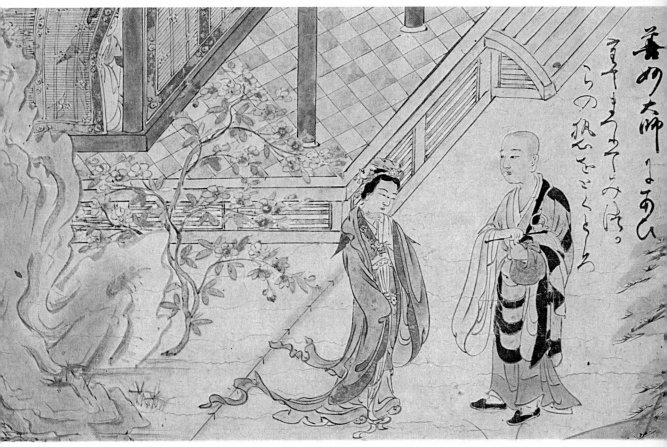

parture and plunges into the sea to follow him, is miraculously transformed into a dragon that guides him safely home. Unlike most emaki, *which dramatize narratives set in Japan, this scroll painting illustrates a story that takes place in China and effectively depicts T'ang Chinese dress and architecture. Kamakura period, 13th century. Kōzan-ji, Kyoto.*

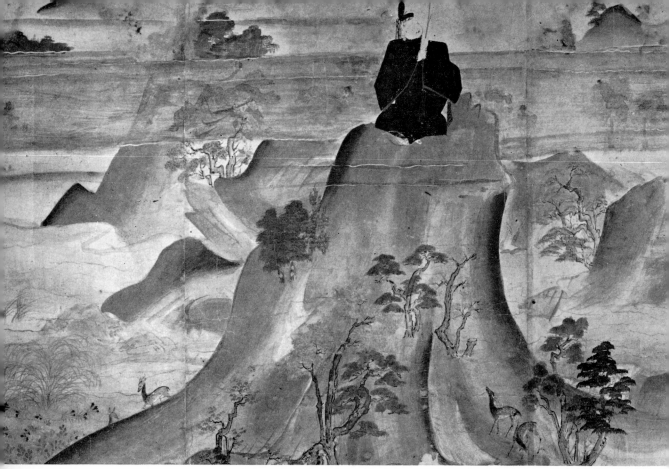

64. Kitano Tenjin Engi. *Kamakura period, 13th century. Kitano Temman-gū, Kyoto.*

emaki naturally depend on their rank and economic situation. The differences between urban and rural life become clear, as do those among different ranks and ages and between sexes, so that we are given some insight into the complex hierarchical system that comprises the fabric of Japanese society.

We see scenes of farming (Plate 60), weaving (Plate 59), and fulling cloth (Plate 115). We also see people enjoying various games and pastimes such as *go,* a board game (Plate 4); *kemari,* a sort of kickball (Plate 87); boating (Plate 34); and cockfighting, which was extremely popular in both aristocratic and plebeian circles (Plate 122). We even see children spinning tops (Plate 83). Plate 50 shows a cherry-blossom party held at the Daigo temple. Noblemen engaged in various activities and games often provide the cen-

tral focus of a scene, while commoners pursuing the same activity make up the background.

There are many scenes of travel—often pilgrimages and visits to shrines (Plates 67, 108) and missionary journeys (Plates 52, 53). Travel is undertaken not merely for pleasure; there is always some excuse for a journey. Most of the travelers are on foot, although the nobility are depicted on horseback, in palanquins, or in carts pulled by oxen (Plates 67, 78). Some *emaki* depict travelers journeying by boat, although this was not a common means of transportation.

The Japanese fondness for melancholy is also reflected in *emaki,* which are filled with depictions of moments of pathos in the lives of the characters. There is the sorrow of separation (Plates 2, 20, 105), of parting from a plum tree (Plate 118), or of watching a

65. Chigo Kannon Engi *(Legends of Chigo Kannon). Kamakura period, 14th century. Murayama Collection, Hyōgo Prefecture.*

66. Haizumi Monogatari Emaki *(Tale of Haizumi). Folk tale. Kamakura period, 14th century. Tokugawa Art Museum, Nagoya.*

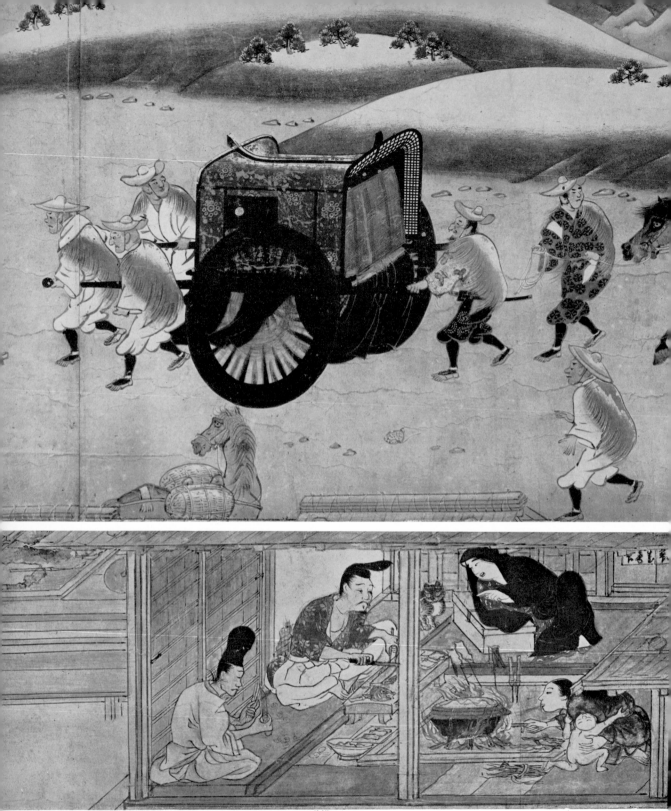

68. Matsuzaki Tenjin Engi. *Kamakura period, 14th century. Bōfu Temman-gū, Yamaguchi Prefecture.*

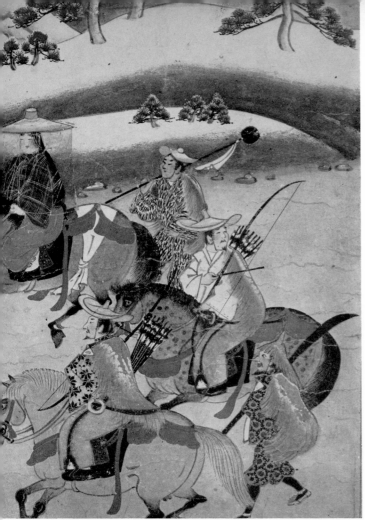

67. Ishiyama-dera Engi. *Kamakura period, 14th century. Ishiyama-dera, Shiga Prefecture.*

69. *(below)* Tōhoku-in Shokunin Uta-awase Emaki. *Kamakura period, 14th century. Tokyo National Museum.*

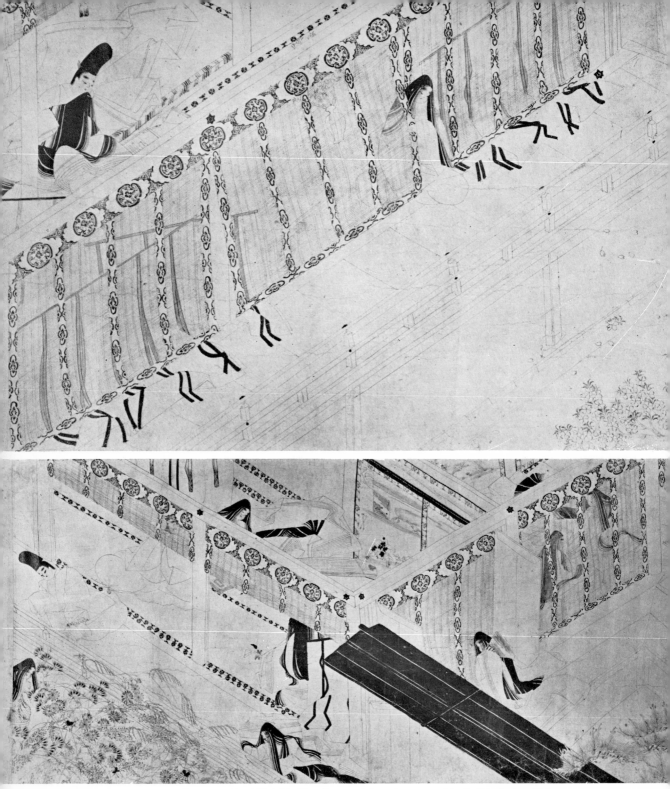

70–71. Toyo no Akari Ezōshi. *Kamakura period, 14th century. Maeda Foundation, Tokyo.*

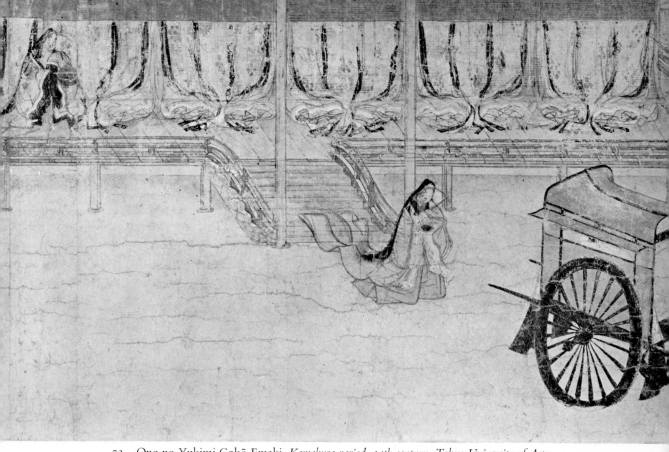

72. Ono no Yukimi Gokō Emaki. *Kamakura period, 14th century. Tokyo University of Arts.*

cherry blossom fall. We see the sorrow of adversity (Plate 75), the misery of solitude (Plate 65), and the pain of jealousy (Plate 5).

The noble melancholy suffered in this world has its complement in the fiery hereafter. The agonies of hell (Plates 46, 94) or existence as hungry ghosts (Plates 35, 49) await the unjust, who in turn bring torment to this life: the *Fukutomi Zōshi* (Story of Fukutomi, Plate 100), for example, depicts treachery among comrades. In the *Genji emaki,* Kashiwagi, who has committed adultery with Prince Genji's wife, is torn between two worlds; mortally ill, he lies in bed, already tormented by his sin (Plate 10). The emotional sequel to this scene is found in Plate 7, which shows Genji pensively holding the baby born to his wife and Kashiwagi, whom he must recognize as his own child. As

Genji reflects on a similar situation in his own youth in which he was the adulterer, he is forced to admit that his present predicament is a just though painful retribution. Because of the conventions for characterization, emotion is invariably better portrayed in the commoner than in the aristocrat. The telling representations of anger (Plates 21, 100), joy and excitement (Plate 101), and surprise (Plates 16, 33) all have commoners as subjects.

Romance in all its forms appears in scroll paintings. Narratives like the *Genji emaki* (Plates 3, 11) and the *Sagoromo Monogatari Emaki* (The Loves of the Courtier Sagoromo, Plate 62) show noblemen with their ladies. One of the underlying themes of the *Kegon-shū Soshi Eden* is the love of a Chinese girl for a Korean monk (Plate 63). And in the *Dōjō-ji Engi* (Legends of

73. Makura no Sōshi Emaki. *Kamakura period, 14th century. Asano Collection, Tokyo.*

Dōjō-ji, Plate 110), we see a passionate woman pursuing a young priest. Homosexual themes also appear: the *Ashibiki Emaki* (Tale of Ashibiki, Plate 107) depicts a monk with a young prince.

The forty-eight scrolls of the fourteenth-century *Hōnen Shōnin Eden* prove to be a most valuable source for social and cultural study. Another work, the *Nenjū Gyōji Emaki* (Annual Rites and Ceremonies), is equally informative, for it depicts such court ceremonies as the emperor's New Year visit to his parents, the New Year banquet given by the imperial consort, the conferring of court ranks, the seven-day religious ritual of Gosai-e at New Year, the dance festivals at New Year, the imperial archery contest, and the Gotō

ritual dedicated to the polar star on the third of March. Because popular festivals such as the Gion-e and the Omi Shinomiya Matsuri (Plate 121) are also included, the value of the *Nenjū Gyōji Emaki* as a historical document is increased.

For generations, *emaki* scholars have been studying scroll paintings whose artists and dates of production are unknown. Although they have finally reached the stage where classification by approximate date of production is possible, the dating is still not precise enough for the kind of research that will really contribute to our knowledge of these paintings as forms of art and as historical records. It is clear that real progress will require the cooperation of scholars from many fields.

4

Selected Individual Emaki

This section contains summaries in alphabetical order of forty-four selected *emaki*. Preceding each critique is the Japanese name of the *emaki*, the English translation, the number of scrolls in existence, the present owner and location, the period in which the *emaki* was executed, and the status of the *emaki* as registered under the 1950 Cultural Assets Protection Law. Plate references follow the summary.

Ban Dainagon Ekotoba

(Story of the Courtier Ban Dainagon)
3 scrolls. Sakai Collection, Tokyo. Heian period (12th century). National Treasure.

In the year 866, during the reign of Emperor Seiwa, Tomo Yoshio, one of the Great Councilors (Ban Dainagon) and the Undersecretary of State, set fire to the Otemmon Gate and falsely accused Minamoto Makoto, the Minister of the Left, of arson. The truth was later revealed and Yoshio was exiled. The *emaki*

that depicts this event is exceptional because it is the first to deal with a historical incident. The artist skillfully took full advantage of the possibilities inherent in the continuous narrative form of *emaki*. He was particularly successful in his handling of groups of people; one of the most exciting passages occurs on the first scroll, where two crowds of people rush from either direction to see the burning gate. The attribution of this *emaki* to Tokiwa Mitsunaga, an artist active in the mid-twelfth century, has recently been proved to be almost certain. (Plates 20, 21, 33)

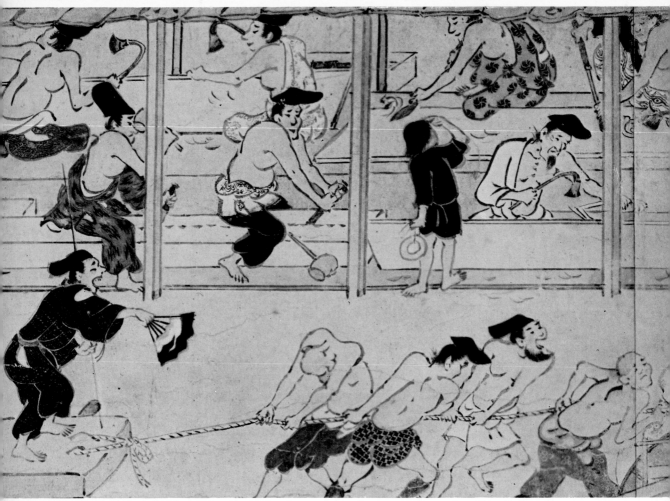

74. Ishiyama-dera Engi. *Kamakura period, 14th century. Ishiyama-dera, Shiga Prefecture.*

75. Kitano Tenjin Engi. *Scroll IV. The cultured poet and minister Sugawara Michizane (845–903) has been exiled to Dazaifu, Kyū- ▷
shū, as a result of false charges brought against him by a rival. In this scene, he takes out the robe he had been given a year ago to the
day, when he had composed a poem in honor of the emperor. Michizane, who appears at the left in white, reminisces about that glorious
day and, unable to hide his grief at his present misfortune, puts his sleeve to his face and weeps. The overgrown, dilapidated house that is
his dwelling place at Dazaifu provides an appropriate setting for this melancholy episode. Kamakura period, 13th century. Kitano Tem-
man-gū, Kyoto.*

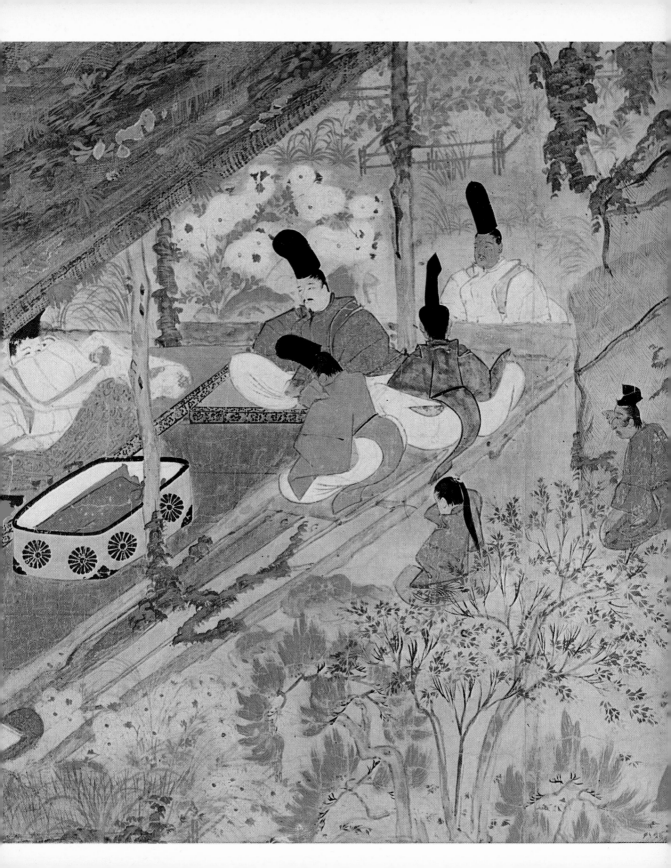

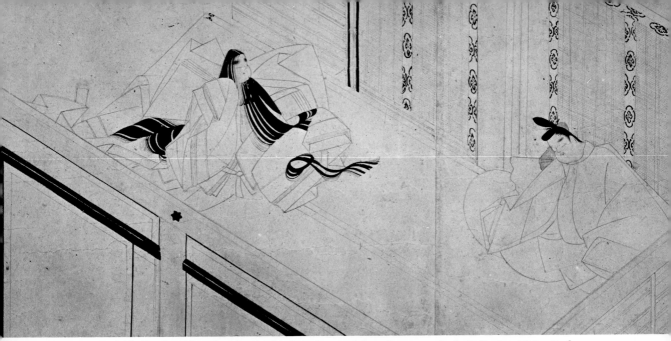

76. Takafusa-kyō Tsuyakotoba Emaki. *Kamakura period, 14th century. Asada Collection, Hyōgo Prefecture.*

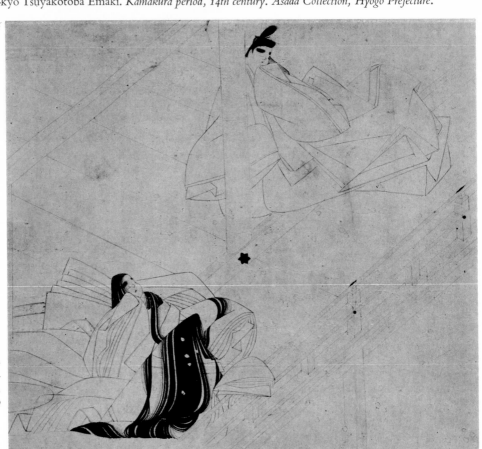

77. Takafusa-kyō Tsu-yakotoba Emaki. *Kama-kura period, 14th century. Asada Collection, Hyōgo Prefecture.*

Boki Ekotoba

(Biography of the Priest Kakunyo)
10 scrolls. Nishi Hongan-ji, Kyoto. Kamakura period (14th century). Important Cultural Property.

This is a pictorial biography of Kakunyo (1270–1351), the third chief priest of the Hongan-ji in Kyoto, one of the head temples of the True Pure Land sect (Jōdo Shinshū). Done in the traditional *yamato-e* style, this *emaki* supplies much important information concerning the way of life and the customs of the period. The artists who created the scrolls were Fujiwara Hisanobu (first and seventh scrolls), Fujiwara Takaaki (second, fifth, and sixth scrolls), and Fujiwara Takamasa (third, fourth, ninth, and tenth scrolls). The painter of the eighth scroll is unknown.

This *emaki* was loaned to the household of the shogun at the request of the shogun Yoshimitsu (r. 1368–94). In 1481, the *emaki* was returned to its owner, but the first and seventh scrolls were missing. In 1482, Fujiwara Hisanobu repainted these two scrolls to replace the lost ones. (Plate 83)

Chōjū Jimbutsu Giga

(Scroll of Frolicking Animals and People)
4 scrolls. Kōzan-ji, Kyoto. Heian and Kamakura periods (12th and 13th centuries). National Treasure.

Each of the four scrolls in *Chōjū Jimbutsu Giga* deals with a different subject. Monkeys, hares, and frogs mimic human beings with great enjoyment in the first and most popular scroll. The second scroll, which is called "Sketches of Birds and Animals," consists of cursory drawings of fifteen kinds of animals, both real and imaginary, such as horses, cows, cocks, lions, dragons, and *kirin*. The third scroll, "Caricatures of Men, Birds, and Animals," is divided into two sections: the first half depicts priests and laymen gambling; the second half shows monkeys, hares, and frogs imitating people, as in the first scroll. The fourth scroll, "Caricatures of Men," is similar to the first half of the third scroll and depicts priests and laymen enjoying various activities. Different interpretations have been given to these scrolls, but since there is no accompanying text, no explanation proves uncontroversial.

The entire *emaki* is executed in ink alone. The work has been attributed to the monk Kakuyū (1053–1140), who is often given the nickname Toba Sōjō, but there is no firm evidence to support this assertion. It is likely that different artists worked on these *emaki*. The date of production is set in the late Heian period (mid-twelfth century) for the first two scrolls and the early Kamakura period for the last two scrolls. The year 1253 is inscribed at the end of the third scroll. (Plates 24–25, 56)

Dōjō-ji Engi

(Legends of Dōjō-ji)
2 scrolls. Dōjō-ji, Wakayama Prefecture. Muromachi period (16th century). Important Cultural Property.

During the reign of Emperor Daigo, in the early tenth century, a married woman fell in love with a young monk who had come from the northern part of Honshū to visit the three Kumano shrines. The monk fled from her, but the woman, disguising herself as a giant snake, pursued him. He hid inside the bell of the Dōjō-ji, but the snake-woman wrapped herself around the bell and blew fire into it until the monk was burned to death. A memorial service later held by the monks of the temple made it possible for the woman and the monk to go to heaven. The story is illustrated in continuous narrative fashion and conversations are written on the pictures, which eliminates the necessity for interpolated textual sections. (Plates 108, 109-110)

E Inga-kyō

(Illustrated Sutra of Cause and Effect)
1 scroll. Jōbon Rendai-ji and other temples, Kyoto. Nara period (8th century). National Treasure.

This *emaki* illustrates the *Sutra of Cause and Effect in the Past and Present,* which relates the activities of the Buddha in his previous existence and describes various legends about the life in which he finally achieved Buddhahood. The scroll reflects the style of an original Chinese version in that the sutra is copied in "regular-style" *(kaisho)* characters of the T'ang period on the lower half of the horizontal format, while the upper portion is reserved for illustrations.

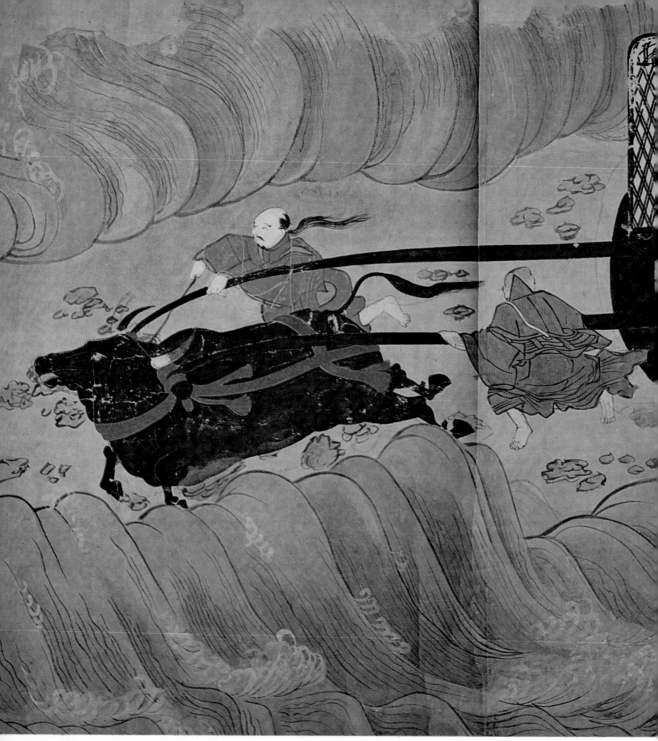

78. Kitano Tenjin Engi. *Scroll V. The Buddhist monk Son'i of the Hōshōbō temple on Mount Hiei is summoned to Kyoto by the emperor to pacify the spirit of Sugawara Michizane, who before his death had declared that his enemies would be haunted until a shrine was built for him (see also Plates 75, 118). On his journey Son'i finds the Kamo River flooded because of a thunderstorm caused by the*

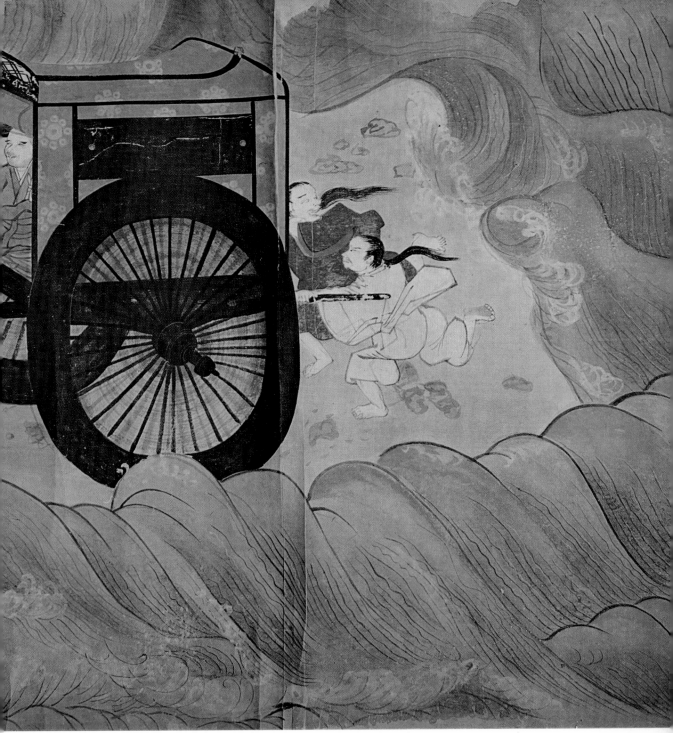

vengeful spirit of Michizane. He forces his oxcart into the swollen stream and, thanks to his faith and the power of the emperor's authority, the waters part and he is able to proceed unharmed. The only calm figure in this dramatic scene is the monk himself, who sits in the oxcart holding prayer beads. Kamakura period, 13th century. Kitano Temman-gū, Kyoto.

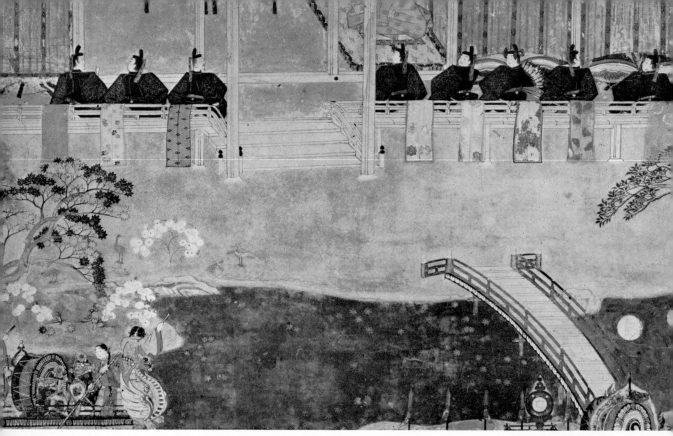

79. Komakurabe Gyōkō Emaki. *Kamakura period, 14th century. Kubo Collection, Osaka.*

80. Haseo-kyō Zōshi. *Kamakura period, 14th century. Hosokawa Collection, Tokyo.*

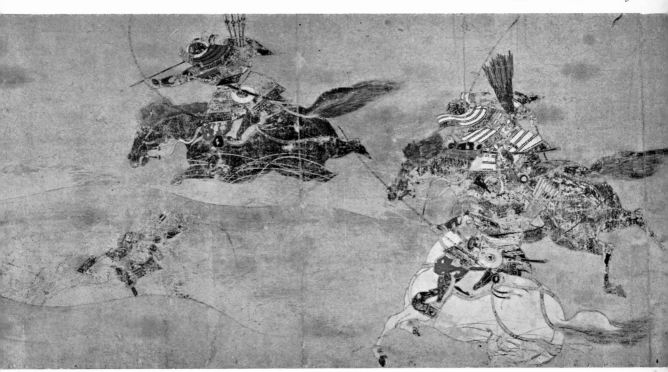

81. Gosannen Kassen Ekotoba. *Kamakura period, 14th century. Tokyo National Museum.*

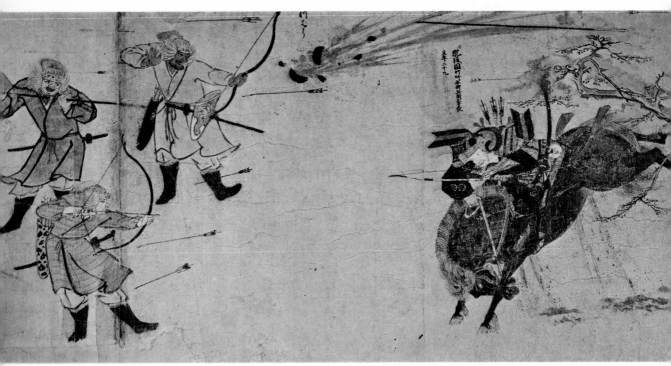

82. Mōko Shūrai Ekotoba. *The thirteenth-century Mongol assaults, the only recorded military invasions in Japanese history, are the subject of this documentary scroll painting. Because Takezaki Suenaga, one of the heroes of the battles against the invaders, commissioned an artist to paint this handscroll in commemoration of his courageous deeds, the paintings focus on him rather than on the whole offensive. In this scene, an episode from the Bun'ei Battle of October 19, 1274, Suenaga and four companions meet a detachment of Mongol troops west of Hakata in Kyūshū. Both Suenaga and his horse have been shot, and he and the others are about to be killed when reinforcements arrive to save them. In the upper middle portion an inscription refers to "gun" (teppō) and near it is a bursting shell. Suenaga is said to have himself added the red arrow shot into his helmet after the scroll painting was finished. Kamakura period, 13th century. Imperial Collection, Tokyo.*

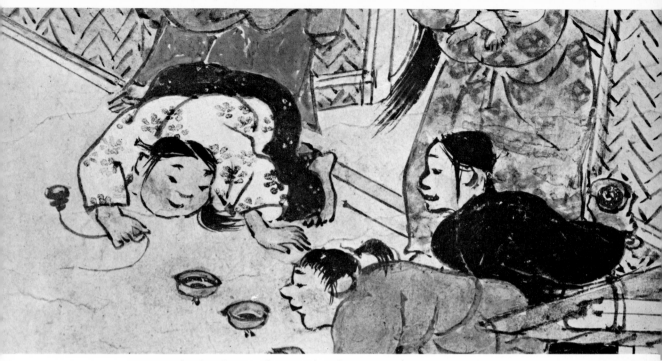

83. Boki Ekotoba. *Kamakura period, 14th century. Nishi Hongan-ji, Kyoto.*

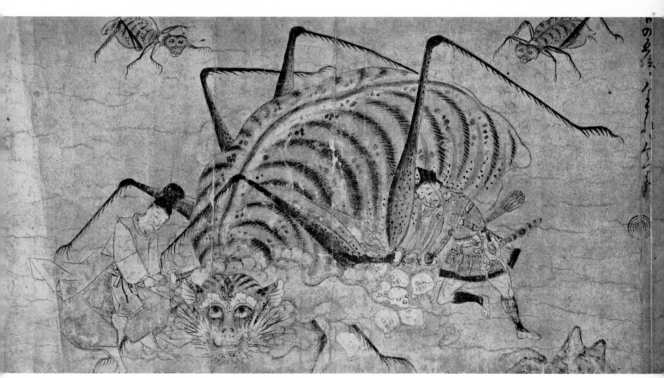

84. Tsuchigumo Zōshi. *Kamakura period, 14th century. Tokyo National Museum.*

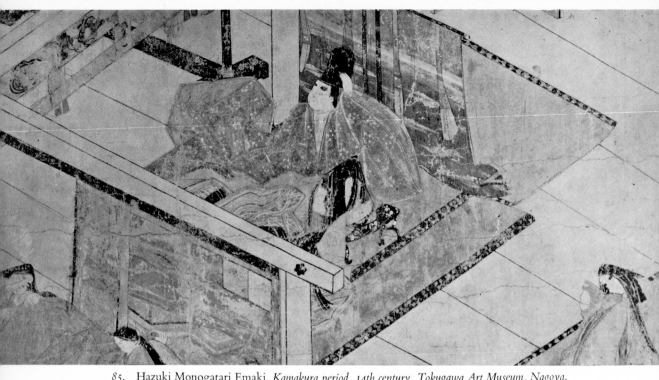

85. Hazuki Monogatari Emaki. *Kamakura period, 14th century. Tokugawa Art Museum, Nagoya.*

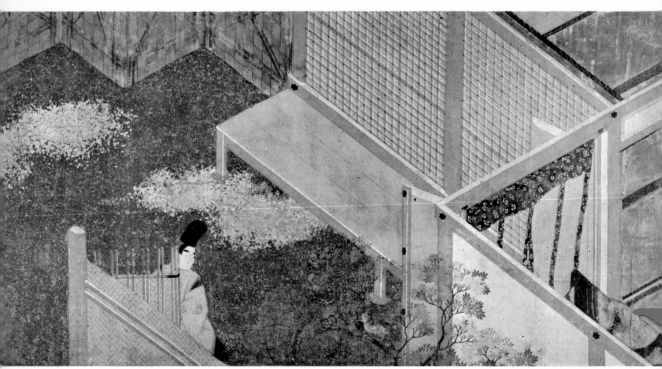

86. Ise Monogatari Emaki. *Kamakura period, 14th century. Kubo Collection, Osaka.*

Other versions of this illustrated Nara-period sutra have been preserved, including one scroll in the Hōon-in in Kyoto, one in the Tokyo University of Arts, and another presently in the hands of the Cultural Properties Protection Commission, Tokyo. All are painted in a simple style derived from paintings of the Six Dynasties period (222–589) in China. (Plate 1)

Eshi no Sōshi
(Story of a Painter)
1 scroll. Imperial Collection, Tokyo. Kamakura period (14th century).

In an ancient tale, a poor painter is appointed the lord of Iyo Province and invites all his relatives to a celebratory feast. However, his fief is stolen soon afterward, and he is left without any source of income. He seeks the assistance of a nobleman, an official magistrate of painting at the Hōshō-ji, but this proves useless. Poor and helpless, the painter makes his son a postulant at a temple of the Shingon sect, and he becomes a Buddhist himself. (Plate 91)

Fukutomi Zōshi
(Story of Fukutomi)
2 scrolls. Shumpo-in, Kyoto. Muromachi period (15th century). Important Cultural Property.

Hidetake, a poor old man, was persuaded by his wife to pray to Dōsojin, a Shintō deity who protects travelers. He dreamed that the deity gave him a small bell. A fortuneteller interpreted the dream and told Hidetake that he would become rich aided by an unexpected voice from within himself. Soon afterward, he learned to dance to the musical sounds of his farts. He was asked to demonstrate his unusual talent to some nobles and he soon became rich because of the damask, brocade, and gold he received from them. Fukutomi, his old neighbor, also a poor man, envied Hidetake's prosperity and acceded to his wife's demands that he become Hidetake's pupil. Hidetake accepted Fukutomi as his student and gave the latter morning-glory seeds which, unbeknown to Fukutomi, induce diarrhea. Consequently, Fukutomi could not control his bowels during the show he performed in front of an assistant chief of the imperial guards,

and he returned home severely beaten. Fukutomi's enraged wife attacked Hidetake in the street and bit him. In this *emaki,* one of the best folk-tale scrolls, conversations are written right onto the illustrations. (Plates 100, 101, 114)

Gaki Zōshi
(Scroll of Hungry Ghosts)
1 scroll. Tokyo National Museum, Tokyo. 1 scroll. Kyoto National Museum, Kyoto. Kamakura period (12th century). National Treasure.

This *emaki* deals with the grotesque hungry ghosts *(gaki)* who haunt various places in hopes of relieving their hunger and thirst and of achieving a more auspicious rebirth. The scroll in the Tokyo National Museum depicts hungry ghosts who crave sex, newborn babies, and excrement; ghosts who run wildly in the wilderness; ghosts who eat hot ashes in the cremation grounds and who wander among the tombs; and ghosts who crave water.

The Kyoto National Museum scroll includes illustrations based on a Buddhist sutra, the *Shōhō Nenjo-kyō,* which explains the six realms of rebirth *(roku-dō).* In Buddhist doctrine, a living being is doomed to the wheel of birth and death and to rebirth in one of these six realms until he achieves enlightenment and release from the bondage of life. The scroll includes such stories as an account in which a disciple of Buddha aids a mother who has been reborn in the realm of the hungry ghosts, the story in which the Buddha succors five hundred ghosts craving water by the Ganges River in India, and the story in which Ananda relieves ghosts with flaming mouths.

Although these two scrolls were painted by different artists, the styles are similar: the lines in both are freely executed and the coloring is faint. The Buddhist doctrine of the six painful realms of rebirth, which is also reflected in the *Jigoku Zōshi* (Scroll of Hell), was widely disseminated among the people during the end of the Heian period and the beginning of the Kamakura period, when society was in a state of unrest because of civil strife and natural disasters. (Plates 35, 49)

Genji Monogatari Emaki
(The Tale of Genji)

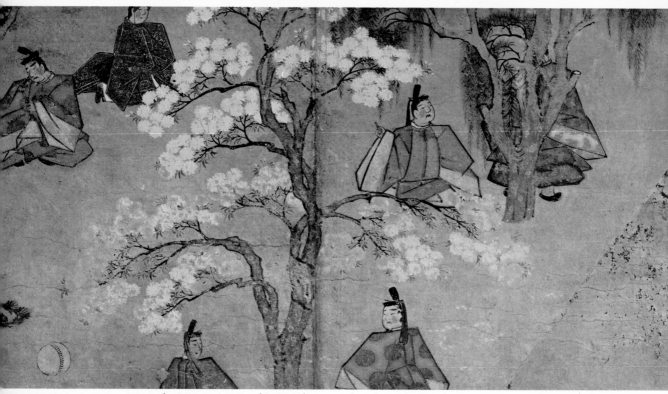

87. Nayotake Monogatari Emaki. *Kamakura period, 14th century. Kotohira-gū, Kagawa Prefecture.*

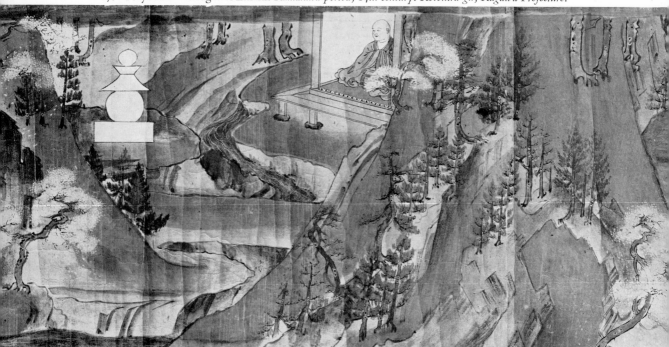

88. Kōbō Daishi Gyōjō Ekotoba *(Biography of Priest Kōbō Daishi). Kamakura period, 14th century. Kyō-ō Gokoku-ji, Kyoto.*

43 sheets. Tokugawa Reimeikai, Tokyo (deposited in Tokugawa Museum, Nagoya). 13 sheets. Gotō Art Museum, Tokyo. Heian period (12th century). National Treasure.

This scroll painting is based on *The Tale of Genji,* a romantic novel about Heian court life written by Lady Murasaki in the early eleventh century. The novel is devoted principally to the love affairs of a handsome young prince and their extremely complicated sequels: Genji's love affairs as a young man; then his relations with his wives, his mistresses, and his children; and finally the lives of his descendants.

The *emaki,* which dates from approximately one century later than the novel itself, must have originally comprised a number of scrolls (possibly twenty, with 100 paintings and 370 sheets of calligraphy) illustrating the fifty-four chapters of the novel. The existing handscrolls, now deposited in the Tokugawa and Gotō art museums, have been cut up into separate pieces of picture and text, and each sheet has been framed for better preservation. The Reimeikai scrolls include fifteen scenes taken from the following chapters: "The Palace in the Tangled Woods," "A Meeting at the Frontier," "Kashiwagi," "The Flute," "Bamboo River," "The Bridge Maiden," "Fern-Shoots," "The Mistletoe," and "The Eastern House." The Gotō Collection contains four scenes from "Listening to a Chirping Insect," "Yūgiri," and "The Law."

The text of the *Genji* scrolls (Plate 8) is written in exquisite calligraphy on paper decorated with gold and silver dust, and flecks and strips of gold and silver paper. Each textual portion is followed by a picture. The paintings have been attributed to Fujiwara Takayoshi, a well-known court painter of the mid-twelfth century, but no clear evidence for this attribution exists. Differences in style make it obvious that the entire work was created by several artists or teams of painters rather than by just one. Four styles of writing in the textual portions imply four calligraphers. (Plates 2, 3, 4, 5, 6, 7, 8, 9, 10, 11)

Haseo-kyō Zōshi
(Tale of Lord Haseo)
1 scroll. Hosokawa Collection, Tokyo. Kamakura period (14th century). Important Cultural Property.

This scroll painting illustrates a mysterious story in which Ki Haseo, a famous scholar and poet of the early Heian period, played a game of *sugoroku* (a kind of backgammon) with a demon who lived in the Sujaku Gate and won a beautiful girl from him. The demon had made the girl out of various parts of the dead bodies of beautiful human beings, and she was supposed to become a real person after a hundred days had elapsed. The demon's only condition was that Haseo promise not to touch her before the hundred days had passed. Haseo, unable to restrain himself, embraced the girl before the appointed period was over, whereupon she dissolved into water and floated away. When he heard about the broken promise, the enraged demon attacked Haseo, who barely escaped with the help of the Shintō god Kitano Tenjin, the subject of the *Kitano Tenjin Engi* (see the entry on page 123). (Plate 80)

Heiji Monogatari Emaki
(The Tale of the Heiji Rebellion)
1 scroll. Tokyo National Museum, Tokyo. 1 scroll. Museum of Fine Arts, Boston. 1 scroll. Seikadō, Tokyo. Kamakura period (13th century). National Treasure (Tokyo National Museum scroll).

This *emaki* is based on a war tale written about 1220 (the *Heiji Monogatari*), which relates the story of the civil war that began in the first year of the Heiji era (1159). This clash in 1159 and an earlier confrontation in the Hōgen era (1156) between the two great rival clans, the Taira (Heike) and the Minamoto (Genji) started the warfare that did not cease until the Minamoto had finally gained supreme power thirty years later. The three extant scrolls of this *emaki* illustrate only the beginning episodes of the Heiji incident; many more scrolls must have been part of the original work. The Boston scroll depicts the chapter describing how Fujiwara Nobuyori and his men attacked the Sanjō Palace of ex-Emperor Goshirakawa and set it on fire on December 9, 1159. The Seikadō scroll (which is an Important Cultural Property) concerns Fujiwara Shinzei. It contains scenes depicting his death and his head gibbeted on the prison gate. The Tokyo National Museum scroll deals with the escape of Emperor Nijō

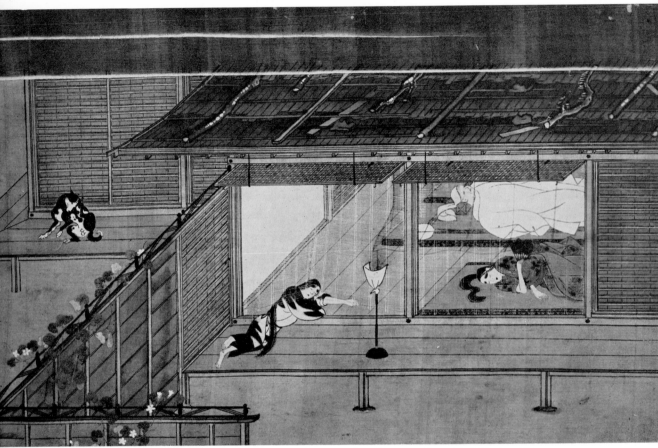

89. Kasuga Gongen Reigen Ki. *Kamakura period, 14th century. Imperial Collection, Tokyo.*

90. Kasuga Gongen Reigen Ki. *Ka-makura period, 14th century. Imperial Col-lection, Tokyo.* ▷

91. Eshi no Sōshi. *Kamakura period,* ▷ *14th century. Imperial Collection, Tokyo.*

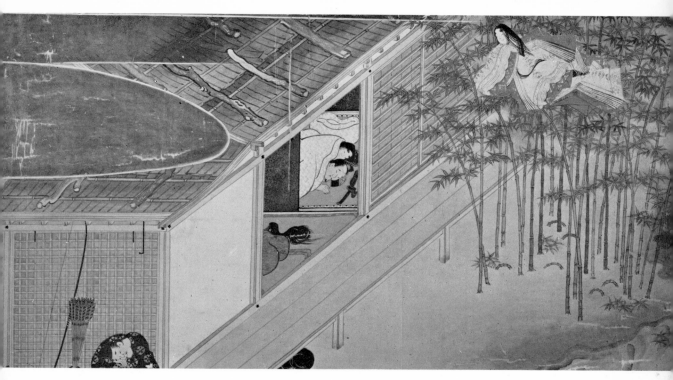

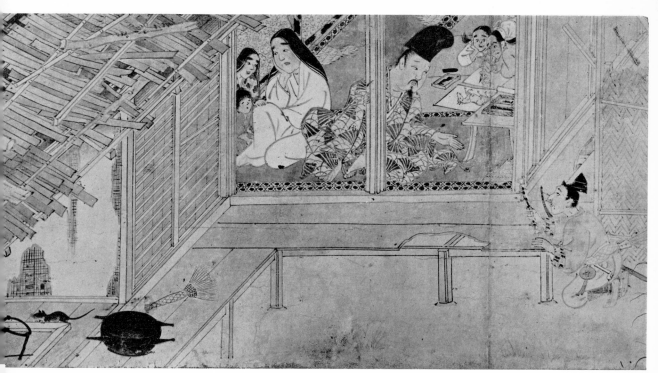

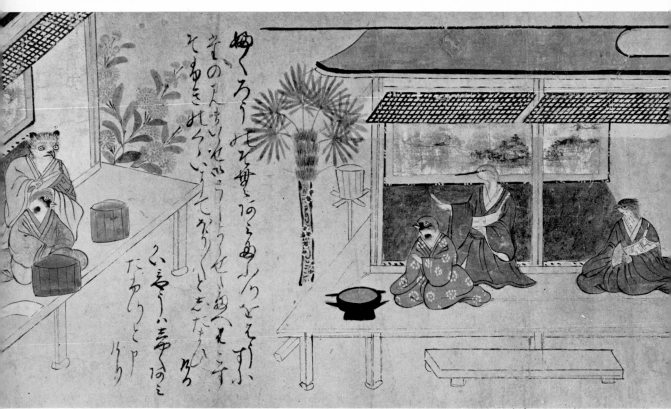

92. Tori Uta-awase Emaki. *Muromachi period, 16th century. Keiō University, Tokyo.*

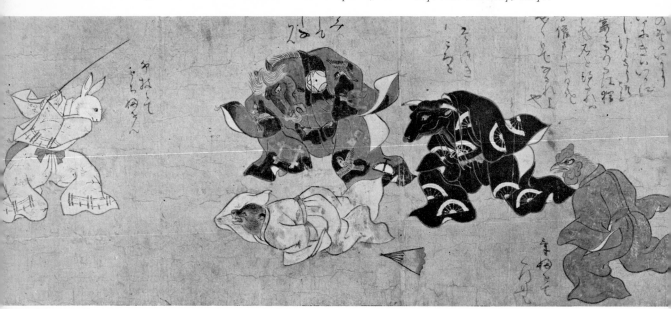

93. Jūnirui Emaki. *Muromachi period, 15th century. Dōmoto Collection, Kyoto.*

and the lady Bifukumon'in to the mansion of Taira Kiyomori at Rokuhara. (Plates 43, 99)

Hōnen Shōnin Eden
(Biography of the Monk Hōnen)
48 scrolls. Chion-in, Kyoto. Kamakura period (14th century). National Treasure.

This *emaki* deals with the life of Hōnen (1133–1212), founder of the Jōdoshū (Pure Land) sect of Buddhism. It also contains biographical sketches of his disciples. Visual representations of the important doctrines of Hōnen make it unique among the pictorial biographies of religious leaders. Tradition has it that Shunshō, the chief priest of the temples of Mt. Hiei, compiled material for the *emaki* from several Buddhist scriptures by order of ex-Emperor Gofushimi. Its production began in 1307 and took ten years, with different artists working on the text and the pictures. Despite various styles, the entire work is successfully executed in bright colors and holds together well as a single unit. It portrays people from all walks of life and is thus an important source for the study of the customs of the time. (Plates 60-61)

Ippen Shōnin Eden
(Pictorial Biography of the Monk Ippen)
11 scrolls. Kankikō-ji, Kyoto. 1 scroll (7th scroll). Tokyo National Museum, Tokyo. Kamakura period (13th century). National Treasure.

This is a pictorial biography on silk of Ippen (1239–89), founder of the Jishū, a branch of the Pure Land sect. Ippen spent most of his life wandering through the country urging people, rich and poor alike, to invoke the name of Amida Buddha in order to obtain salvation. He led both priests and laymen in the *odori nembutsu,* the invocation of the name of Amida Buddha while marching in a circle to the accompaniment of musical instruments such as the gong or drum.

The biographical text was written by Seikai, an adherent of Ippen and the founder of the Kankikō-ji. The illustrator was En'i, who held the title of Hōgen, an honorary title given by the emperor to scholarly Buddhist priests. Completed in 1299, ten years after Ippen's death, the work is regarded as a reliable record of the customs and habits of his time. This scroll painting is particularly noteworthy for the scenic panoramas that provide the background illustrations for Ippen's travels. In fact, the figures often seem engulfed by the landscape, in the Chinese fashion, although the artistic treatment of the landscape lies definitely within the *yamato-e* style. (Plates 39, 40, 52, 53)

Ise Shin Meisho Uta-awase Emaki
(Poetry Contest on Newly Selected Scenic Spots in Ise)
1 scroll. Ise Shrine Administration Agency, Mie Prefecture. Kamakura period (13th century). Important Cultural Property.

In the Einin era (1293–99), the priests of the Ise Shrine selected ten scenic spots in the vicinity of their establishment and held a *waka* poetry contest in which the beauty of these locations was articulated. The prize poems were illustrated and made into two *emaki* scrolls, of which only the second remains. Unlike most *emaki,* it is devoted solely to landscape. (Plate 115)

Ishiyama-dera Engi
(Legends of Ishiyama-dera)
7 scrolls. Ishiyama-dera, Shiga Prefecture. Kamakura period (14th century). Important Cultural Property.

This *emaki* illustrates the legendary origin of the Ishiyama-dera, which the monk Rōben established in the mid-eighth century with Nyoirin Kannon as its principal deity. After depicting many miraculous occurrences, the scroll ends with Emperor Godaigo's dedication of a manor to the temple in commemoration of his enthronement.

It is generally agreed that the first three scrolls were painted by Takashina Takakane, the fourth by Tosa Mitsunobu, and the fifth by Awataguchi Takamitsu. The last two of the seven are later additions painted by Tani Bunchō during the Edo period. Thus the work of three different periods—the Kamakura, the Muromachi, and the Edo—is represented in this scroll painting. (Plates 67, 74)

Jigoku Zōshi
(Scroll of Hell)
1 scroll. Tokyo National Museum, Tokyo. 1 scroll.

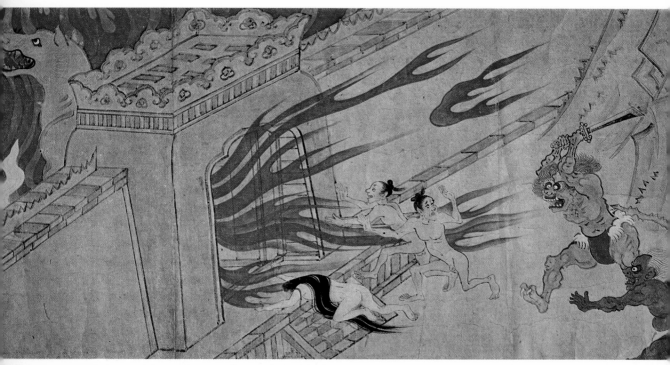

94. Yata Jizō Engi. *This scroll painting features the legends of Yata-dera temple and its principal deity Jizō, and includes a section on the high priest Mammei's travels in hell, from which this scene is taken. Here, two vicious demons, with two-toed feet, grotesque faces, and overly muscular bodies, are forcing unfortunate sinners into the fires of hell. Kamakura period, 14th century. Yata-dera, Kyoto.*

95. Zuijin Teiki Emaki. *The prestigious imperial cavalry, which escorted the nobility on various occasions, is the subject of this* ▷ *exquisite monochrome scroll painting. Only the faces and the trappings of the horses are faintly colored. Although several cavalrymen from various periods are portrayed, the emaki has no plot. In this scene Hata Hisanori is calmly engaged in taming a spirited horse. His face is painted in the nise-e manner, a modified form of realistic portraiture that developed from the late twelfth century onward. Kamakura period, 13th century. Okura Museum, Tokyo.*

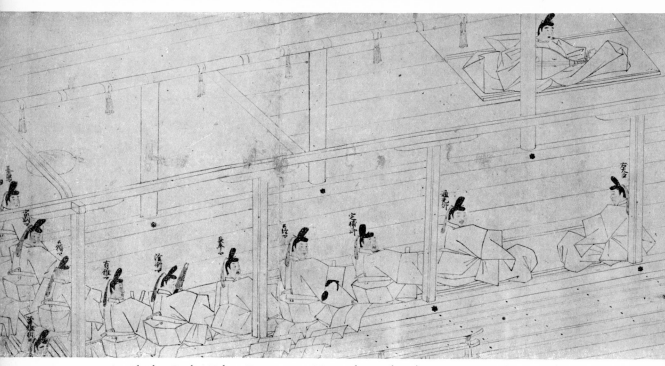

96. Chūden Gyokai Zukan. *Documentary. Muromachi period, 14th century. Kujō Collection, Tokyo.*

97. Sairei Zōshi *(Scroll of Festival Scenes). Documentary. Muromachi period, 15th century. Maeda Foundation, Tokyo.*

98. Sanjūni-ban Shokunin Uta-awase Emaki. *Muromachi period, 15th century. Matsushita Collection, Osaka.*

99. Heiji Monogatari Emaki. *Among the few surviving emaki with military themes, this scroll painting is one of the most famous. The Heiji scrolls depict events from the civil war waged between the Taira and Minamoto, two rival clans of the twelfth century. The skillful portrayal of groups of people and of architecture by the use of finely executed lines and clear colors make this scroll an outstanding*

example of Kamakura emaki art. Here Emperor Nijō, disguised as a court lady, tries to escape from the Sakuhei Gate at the back of his palace and is questioned by rebels. Kamakura period, 13th century. Tokyo National Museum.

100. Fukutomi Zōshi. *Muromachi period, 15th century. Shumpo-in, Kyoto.*

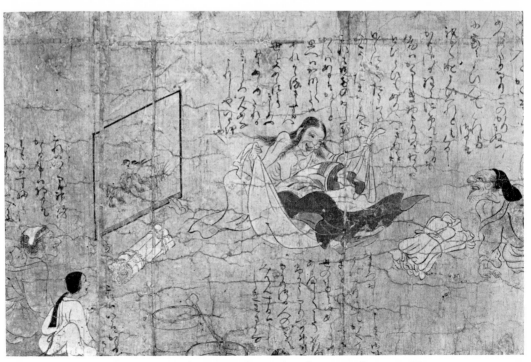

101. Fukutomi Zōshi. *Muromachi period, 15th century. Shumpo-in, Kyoto.*

Nara National Museum, Nara. Kamakura period (12th century). National Treasure.

This *emaki* depicts different realms within the Buddhist hell, in which there are eight principal hells and sixteen subsidiary hells for each principal one. Each scene in these scrolls is preceded by a commentary describing it. The Tokyo National Museum scroll illustrates four subsidiary infernos within the hell of screams as described in the *Shōhō Nenjo-kyō*. They are the hell of the dog and eagle of hot iron; the hell of worms; the hell of smoke, fire, and fog; and the hell of rain, flame, and stones. The Nara Museum scroll depicts the infernos of excretion, measure, the iron mortar, the giant cock, black clouds, pus and blood, and the hell of foxes and wolves. These are seven of the eight infernos mentioned in another sutra, the *Kisei-kyō*. Both these sutras describe the six realms of existence and focus on hell as one of these horrible regions.

The scroll paintings depict the suffering of those who committed such sins as theft, murder, or adultery in their previous existences. Despite their often disgusting subject matter, many people are attracted by the power and grandeur of these scrolls. Although the artist is not known, the contents and style of the work lead one to believe it was done by a Buddhist monk-painter active at the end of the twelfth century. (Plate 46)

Jūnirui Emaki
(Poetry Contest of the Twelve Zodiac Animals)
3 scrolls. Dōmoto Collection, Kyoto. Muromachi period (15th century). Important Cultural Property.

The twelve birds and animals of the zodiac held a poetry competition and appointed the deer as judge. The badger, envious of the deer because everyone entertained him, tried to force the other animals to make him a judge so that he could enjoy the same privileged position. He not only failed in his endeavor but was roundly rebuked. Feeling insulted, he gathered together his kin and attempted a nighttime raid of revenge, but this also ended in failure. The badger finally entered the priesthood of the Pure Land sect. (Plate 93)

Kasuga Gongen Reigen Ki
(The Kasuga Gongen Miracles)
20 scrolls. Imperial Collection, Tokyo. Kamakura period (14th century).

These twenty scrolls were dedicated to the Kasuga Shrine in March 1309 by Saionji Kinhira (1264–1315), a member of the illustrious Fujiwara family and current Minister of the Left. Illustrating the miraculous virtues of the gods of the Kasuga Shrine, the tutelary divinities of the Fujiwara family, they begin with a scene in which a daughter of a lord of the old and honored Tachibana clan announces an oracle, and they end with the miracle of sacred fire flying into the shrine, which was purported to have occurred in 1304. The illustrations for the entire work were meticulously executed by Takashina Takakane, the head of the court atelier; the text was written by members of the clan. This scroll painting ranks as one of the masterpieces of the late Kamakura period. (Plates 89, 90)

Kegon Gojūgo-sho Emaki
(The Pilgrimage of Zenzai Dōji in Fifty-five Stages)
1 scroll. Tōdai-ji, Nara. Heian period (12th century). National Treasure.

This scroll painting is also called the *Zenzai Dōji Emaki* or *The Scroll of the Boy Zenzai* because it depicts the travels of Zenzai who, instructed by Monju, the Bodhisattva of wisdom, journeyed around India inquiring of fifty-three saints and deities the way to salvation. The chapter in the *Kegon Sutra* from which this *emaki* was adapted tells us that the boy met his master again at the end of his pilgrimage, was led to the Bodhisattva Fugen, the right-hand attendant of Sākyamuni Buddha, and finally attained enlightenment.

In a square above each portion of the *emaki* is written the rank and name of each saint or deity, the location of his abode, and a description of the scene. Zenzai and the various saints and deities are depicted in either landscape or palatial settings. Japanese taste predominates in the light brushstrokes and faint, delicate coloring; the architectural designs and the clothing, however, are of Chinese inspiration. Part of this *emaki* was cut up during the Meiji era (1868–1912), and the frag-

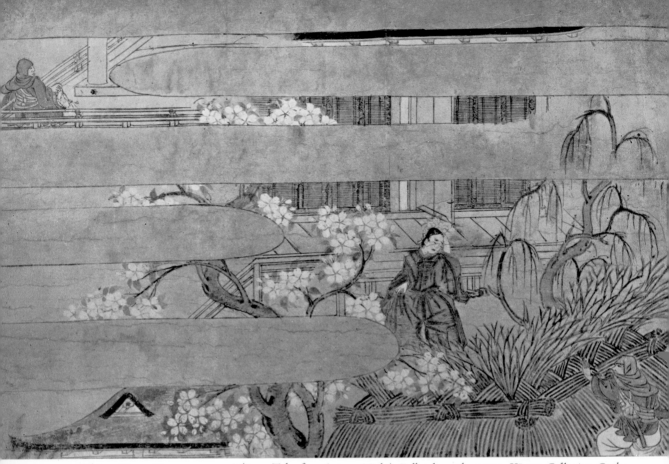

102. Aki no Yo no Nagamonogatari *(Long Tale of an Autumn Night). Folk tale. 15th century. Kōsetsu Collection, Osaka.*

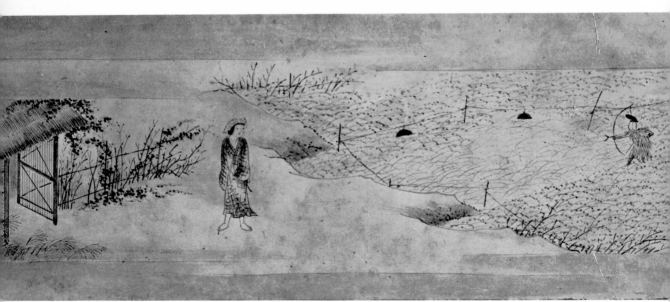

103. Bakemono Zōshi *(Tale of Ghosts). Folk tale. Muromachi period, 16th century. Mizukami Collection, Tokyo.*

ments have fallen into the hands of various collectors. (Plates 22, 23)

Kegon-shū Soshi Eden

(Biographies of the Patriarchs of the Kegon Sect)
6 scrolls. Kōzan-ji, Kyoto. Kamakura period (13th century). National Treasure.

This *emaki,* also known as *Kegon Engi* (Legends of the Kegon Sect), is a pictorial biography of Gishō (Ui Sang) and Gengyō (Wŏn-hyo), Korean monks who established the Kegon sect of Buddhism in Korea in the late seventh century. The two monks decided to set out for China, but Gengyō changed his mind on the way and returned home to practice solitary meditation. Gishō, however, persevered and began his studies in China, where he came to be loved by a beautiful Chinese girl named Zemmyō (Shan-miao). When he had completed his Buddhist training, he started on his voyage home. The girl heard of his departure and hurried to the harbor, but the boat had already set sail. She threw herself into the water and was changed into a dragon that then protected Gishō's boat on the journey. Both Gishō and Gengyō became learned monks of high reputation.

This *emaki,* which may have been influenced by Chinese painting of the Sung dynasty, is characterized by fluid linework and the use of thinly coated colors. (Plates 36, 63)

Kibi Daijin Nittō Ekotoba

(Minister Kibi's Visit to China)
4 scrolls. Museum of Fine Arts, Boston. Kamakura period (13th century).

Kibi Makibi, a scholarly minister of the Nara period, went in the eighth century to China as a Japanese envoy and had to undergo a series of tests conducted by Chinese court officials to measure his intelligence and skill. The spirit of Abe Nakamaro, Kibi's predecessor who had himself been tested and treated harshly by the Chinese, disguised itself as a demon and helped make possible Kibi's success in the tests set for him.

The illustrations are rich in color, as are all *tsukuri-e* works. Originally painted in one scroll that was 24.4 meters long, this *emaki* was the longest of all extant ones until it was cut into four scrolls several years ago. (Plate 41)

Kitano Tenjin Engi

(Legends of Kitano Tenjin Shrine)
8 scrolls. Kitano Temman-gū, Kyoto. Kamakura period (13th century). National Treasure.

This *emaki* depicts the rather complicated and bizarre events leading to the founding of the Kitano Tenjin Shrine in Kyoto. The shrine was established to appease the vengeful spirit of Sugawara Michizane (845–903), an erudite scholar and poet and a distinguished government minister, who died in exile as a result of false charges brought against him by a rival. It was said that on his deathbed he uttered curses with alarming effect and that his spirit would continue its deviltry until a shrine was built to pacify it. The *emaki* is divided into four parts: a biographical account of Michizane's experiences; a depiction of the havoc wrought by his spirit after death; the construction of the Kitano Shrine in which Michizane was deified as Tenjin, the savior of falsely accused people and a god of literature and music; and finally, a depiction of the miracles connected with this shrine. The *emaki* also includes the experiences of Nichizō, a monk of the tenth century who traveled through the six realms of existence—heavenly beings, human beings, angry demons, beasts, hungry ghosts, and hell.

This *emaki* is wider than most handscrolls: it measures 52 cm vertically. The mineral pigment colors are bright, the brushstrokes free, and the descriptive power strong. The work is often called the Jōkyū scroll painting because of the following statement in the first textual portion: "From Emperor Ichijō's first visit to the Kitano Tenjin in 1004 to the present, the first year of Jōkyū (1219), nineteen generations of emperors have worshiped the Kitano Tenjin for 216 years." The year of production of this *emaki* is usually considered to be approximately the first year of Jōkyū, or 1219. (Plates 64, 75, 78)

Kokawa-dera Engi

(Legends of Kokawa-dera)
1 scroll. Kokawa-dera, Wakayama Prefecture. Kamakura period (13th century). National Treasure.

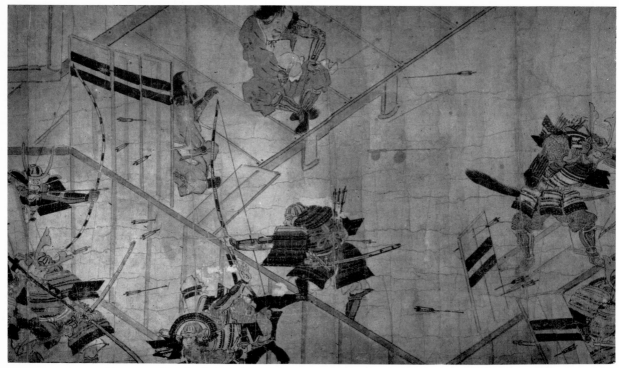

104. Yūki Kassen Ekotoba *(The Yūki Battle). Muromachi period, 15th century. Hosomi Collection, Osaka.*

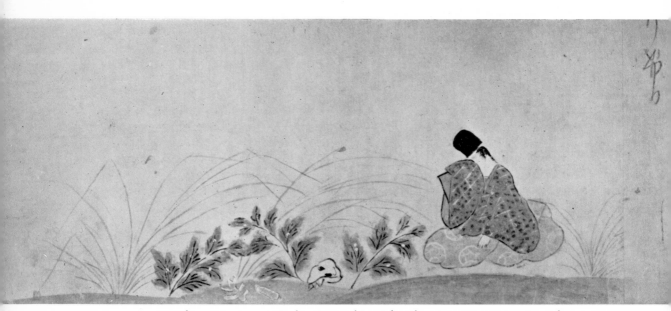

105. Matsuhime Monogatari Emaki. *Muromachi period, 16th century. Tōyō University, Tokyo.*

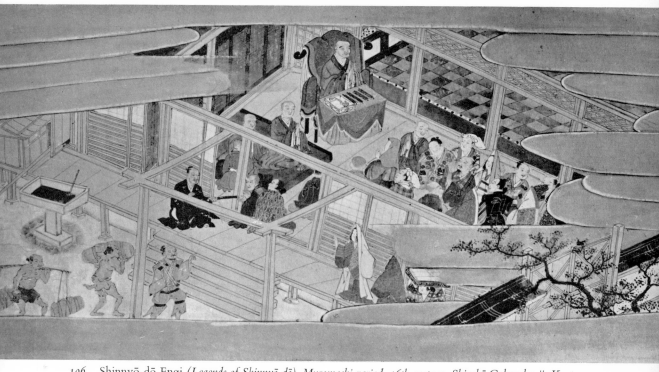

106. Shinnyō-dō Engi *(Legends of Shinnyō-dō). Muromachi period, 16th century. Shinshō Gokuraku-ji, Kyoto.*

107. Ashibiki Emaki. *Muromachi period, 15th century. Itsuō Art Museum, Osaka.*

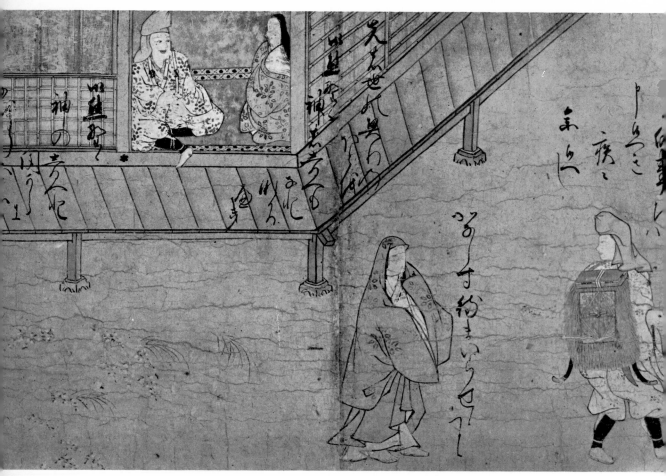

108. Dōjō-ji Engi. *Muromachi period, 16th century. Dōjō-ji, Wakayama Prefecture.*

This *emaki* illustrates two miraculous legends concerning the Thousand-armed Kannon (Senju Kannon), the principal deity of Kokawa-dera. The first miracle occurred in the eighth century and involved a hunter living in Kii Province. He set a trap in the mountains and later noticed a shining spot near it. He then built a hut there, hoping that at some future time he could obtain a Buddhist image and build a temple at the place. One day a boy came to his house and asked for lodging. The request was granted and the boy in gratitude offered to make a Buddhist image on the condition that the hunter would not visit the hut for seven days. On the eighth day the hunter returned and found a dazzling golden image of the Thousand-armed Kannon, but he could find no trace of the boy.

The second story concerns the sick daughter of a wealthy man living in Kawachi Province. A boy came to visit and cured her by reciting a magic spell from a sutra. He refused the treasure the wealthy man offered, but accepted a red skirt and a small knife from the daughter. He left, informing the family of his address: Kokawa, Naka County, Kii Province. The following year the wealthy man and his family visited the place and found a small hut on the mountainside. They opened the door and saw a resplendent Thousand-armed Kannon holding in its hands the red skirt that the daughter had given the boy the year before. Realizing that the boy was an incarnation of the Bodhisattva Kannon, the whole family entered monastic life. (Plate 45)

Komakurabe Gyōkō Emaki
(An Imperial Visit to the Horse Race)
1 scroll. Seikadō, Tokyo. 1 scroll. Kubo Collection, Osaka. Kamakura period (14th century). Important Cultural Property.

This *emaki* is based on the chapter "Horse Races" from the *Eiga Monogatari* or *Tale of Splendor,* a work written in the late eleventh century dealing with the history of the imperial court. The Seikadō scroll illustrates the visit of Jōtōmon'in Akiko, the dowager empress, to Kaya-no-in, the mansion of Fujiwara Yorimichi, on September 14th in the first year of Manju (1024). The Kubo scroll depicts the visit of Emperor Go-ichijō and his consort to the same mansion on September 19th of the same year. (Plate 79)

Makura no Sōshi Emaki
(The Pillow Book)
1 scroll. Asano Collection, Tokyo. Kamakura period (14th century). Important Cultural Property.

This scroll painting is based on the *Pillow Book (Makura no Sōshi),* a witty collection of impressions and events written by the learned and often acerbic court lady Sei Shōnagon in the early eleventh century. The scene showing the lady of the Shigeisa Palace visiting her sister, Empress Sadako, in the Ichijō Palace is among the seven scenes in this scroll.

The pictures are drawn almost exclusively in black ink, with darker tints of black for hair, eyebrows, and furniture, and a few faint touches of red for the lips. (Plates 73, 111)

Matsuhime Monogatari Emaki
(Tale of Matsuhime)
1 scroll. Tōyō University, Tokyo. Muromachi period (16th century).

This scroll painting depicts the story of a courtier who fell in love with and married Matsuhime, the daughter of an assistant chief of the imperial guard. His parents, however, did not approve of their son's marriage, since the girl had neither influential friends nor wealth. One day, when their son was away from home, they induced the bride to go out into a field of pampas grass, where one of their men killed her. The groom spent anguished days searching for his bride. One autumn evening, he saw her ghost and followed it into a thatched hut, where it told him the entire story. When dawn came, he found only a skull in the desolate field. Later, the young man became a monk and wandered over the countryside.

The painting was probably executed by an amateur painter, which helps explain its unique, charmingly childish style. The date 1526 appears at the end of the *emaki*. (Plates 105, 117)

Matsuzaki Tenjin Engi
(Legends of Matsuzaki Tenjin Shrine)

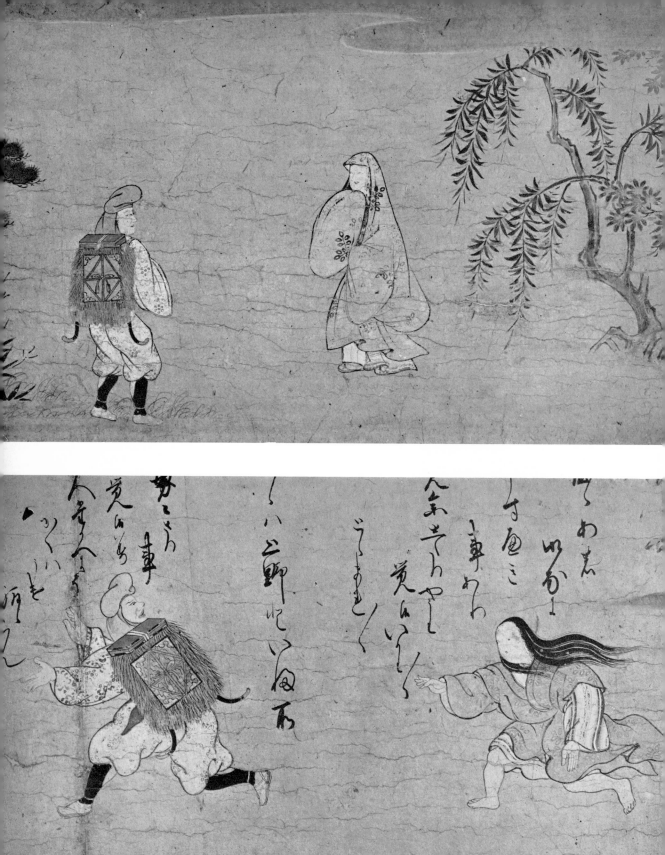

さてわれ
いかゞ

すさきく
車わる

今そもかやし
いかにも

うまほく

くはをのにいゝめあ

男をか
のは
車

人もくちを
いくさを

いくゝを
切つし

111. Makura no Sōshi Emaki. *Part II. This scroll painting is based on* The Pillow Book, *an entertaining and witty collection of impressions and events of Heian court life written by the observant court lady, Sei Shōnagon, in the early eleventh century. The scene shown here illustrates an episode that reveals Shōnagon's great learning. One May evening, some courtiers passed by the chambers of the empress. When the ladies inside wondered who they were, one man thrust a branch of bamboo into the room, suggesting a double meaning for "this gentleman," an obscure term for bamboo derived from Chinese literature. Opening the sliding door, Sei Shōnagon (shown in the center foreground) found the bamboo and said immediately, impressing everyone, "It was this gentleman." The lady in the inner room at the upper right is the imperial consort. Among the various features typical of the courtly tradition in emaki art shown in this monochrome (hakubyō) scroll painting is hikime-kagihana, the stylized convention used to portray the facial features of aristocrats. The nobility were trained to conceal their emotions behind impassive faces, and the ability to do this was considered a mark of good breeding. Respecting this ideal, artists seldom took liberties in their depictions of members of the upper classes. Kamakura period, 14th century. Asano Collection, Tokyo.*

◁ 109–110. Dōjō-ji Engi. *Muromachi period, 16th century. Dōjō-ji, Wakayama Prefecture.*

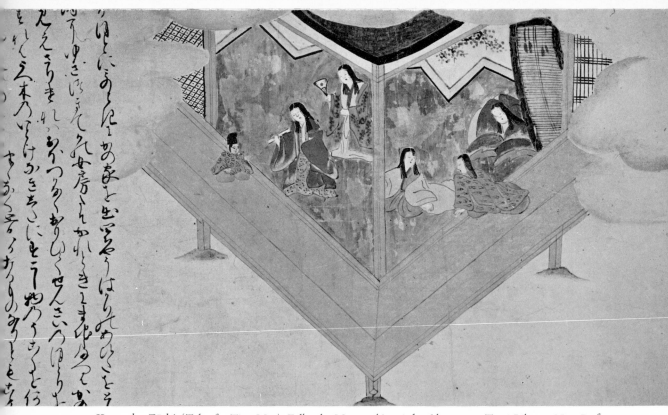

112. Ko-otoko Zōshi *(Tale of a Tiny Man). Folk tale. Muromachi period, 16th century. Tenri Library, Nara Prefecture.*

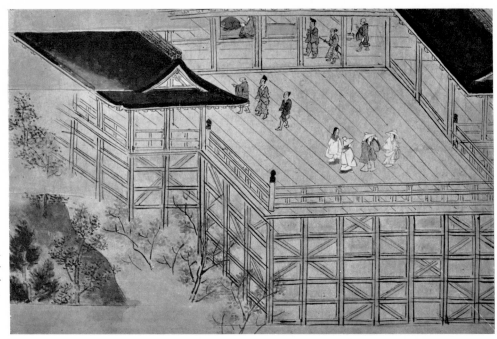

113. Kiyomizu-dera Engi. *Muromachi period, 16th century. Tokyo National Museum.*

6 scrolls. Bōfu Temman-gū, Yamaguchi Prefecture. Kamakura period (14th century). Important Cultural Property.

This *emaki* illustrates the biography of Sugawara Michizane, the miraculous deeds performed by his spirit after death, and the story of the building of the Matsuzaki Shrine, later renamed Bōfu Temman-gū. The content of these scrolls does not correspond to that of the *Kitano Tenjin Engi* of the thirteenth century. (Plates 68, 118)

Mōko Shūrai Ekotoba
(The Mongol Invasion)
2 scrolls. Imperial Collection, Tokyo. Kamakura period (13th century).

This *emaki* was executed shortly after the Mongol invasions of 1274 and 1281 at the request of the general Takezaki Suenaga to commemorate his own courageous deeds. Informed of the attack of the Mongols in 1274, Suenaga led his men to Hakata in Kyūshū, fought the enemy bravely, and repulsed them. He was also victorious in a sea battle against the would-be invaders in 1281.

The *emaki* is divided into three parts: a depiction of Suenaga's triumphs, scenes in which Suenaga reports his success to the Kamakura government, and illustrations of the battle of 1281. The scrolls are devoted exclusively to the brave deeds of Suenaga and do not deal with the entire Mongol offensive. Nevertheless, the battle scenes, with their detailed depictions of the armor and costumes of the warriors, provide precious information about this major historical event. (Plate 82)

Murasaki Shikibu Nikki Emaki
(Diary of Lady Murasaki)
1 scroll. Hachisuka Collection, Tokyo. 1 scroll. Fujita Art Museum, Osaka. 6 scenes. Gotō Art Museum, Tokyo. 1 scroll. Hinohara Collection, Tokyo. Kamakura period (13th century).

The scenes in this *emaki* were inspired by incidents described in the *Murasaki Shikibu Nikki,* the diary of Lady Murasaki Shikibu (c. 978–1015), author of *The Tale of Genji.* The various scrolls, now owned by different collectors and museums, must have originally constituted a single set. The first scene in time illustrates the feast held on September 13, 1008, to celebrate the birth of Prince Atsunari, a son of Emperor Ichijō. The last scene illustrates the fiftieth-day-after-birth feast held on January 15, 1010, to commemorate the weaning of another imperial prince, Atsunaga. Judging from the interval between the incidents, scholars feel that the original *emaki* must have comprised an even greater number of scrolls than are extant today.

The *tsukuri-e* technique is employed in this *emaki,* and gold and silver powders mixed with diluted animal glue are also used extensively. The color tones are elegant and the overall design is richly decorative. (Plates 34, 58)

Nayotake Monogatari Emaki
(Tale of a Young Bamboo)
1 scroll. Kotohira-gū, Kagawa Prefecture. Kamakura period (14th century). Important Cultural Property.

This *emaki* was adapted from the *Tale of a Young Bamboo (Nayotake Monogatari).* In March one year, when a kickball game was held in the garden inside the Watoku Gate, Emperor Gosaga saw a beautiful girl among the people in the audience and sent an attendant of the sixth rank to inquire after her. She told the man to recite to the emperor a poem about a young bamboo; then she fled. The poem was this:

> A young bamboo—
> Do not do anything to it
> Even though it is too tall
> by a node or two . . .

The attendant kept searching for her, and when he finally found her, handed her a love letter from the emperor. The woman, though married to a court official, gave herself to the emperor. (Plate 87)

Nenjū Gyōji Emaki
(Annual Rites and Ceremonies)
16 scrolls. Tanaka Collection, Tokyo. Edo period (17th century).

This handscroll was originally commissioned as a

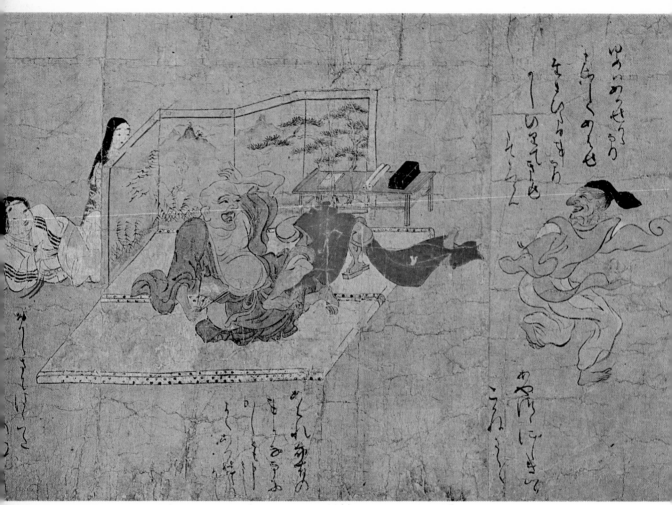

ゆうめつせうり
ムっくのうせ
せ一ひうるうり
一けつてらめ
ると二

ゆ門にいまて
こ二とし

114. Fukutomi Zōshi. *This humorous tale concerns a man who learned to dance to the musical sounds of his farts. Here the hero Hidetake demonstrates his newly acquired skill to the fortuneteller who had predicted that he would become rich through a "voice from within himself." Hidetake later performs before the nobility and receives many rich gifts, thus arousing the envy of his neighbor Fukutomi, whom he deceives into disgracing himself when he tries to imitate Hidetake's feat. Conversations are written directly onto the illustrations of this emaki, one of the best of the folk-tale (otogi zōshi) scrolls. Muromachi period, 15th century. Shumpo-in, Kyoto.*

115. Ise Shin Meisho Uta-awase Emaki. *Poetry contests, a sophisticated form of entertainment in medieval Japan, were often illustrated in handscrolls. The theme of the contest depicted in this scroll painting was the scenic spots in the vicinity of Ise Shrine. Unlike most emaki, the illustrated portions, which alternate with the poetry that inspired them, are devoted to landscape. The disproportionately large plants and reeds and the red-leafed maple tree, all swaying in the wind, convey the mood of a cool and breezy autumn day. In the left foreground is a small house, inside which a woman can be seen fulling cloth. Kamakura period, 13th century. Ise Shrine Administration Agency, Mie Prefecture.*

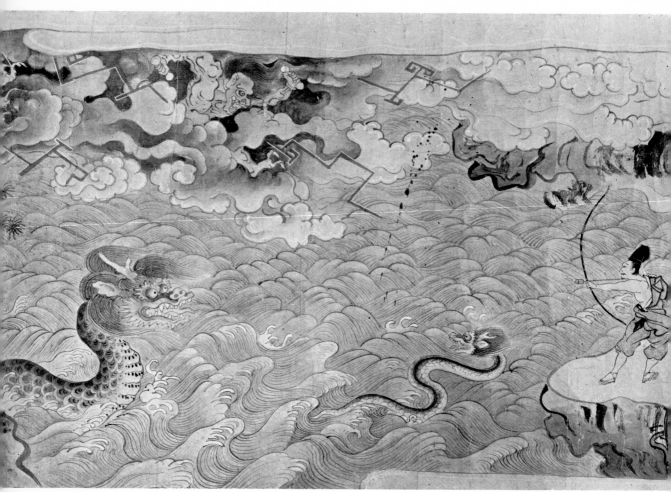

116. Tawara Tōda Emaki (*Adventure of Tawara Tōda*). *Folk tale. Muromachi period, 16th century. Konkai Kōmyō-ji, Kyoto.*

sixty-scroll *emaki* by ex-Emperor Goshirakawa (1127–92) after his abdication in 1158 to serve as a pictorial record of the annual festivals of the imperial court. It chronicles in great detail twelfth-century life in both aristocratic and bourgeois circles. Mitsunaga, who is credited with having painted the *Ban Dainagon Ekotoba,* is said to have supervised these sixty scrolls as well.

Only sixteen scrolls remained by the beginning of the seventeenth century, and in 1626 the reigning emperor, Gomizuno-o (r. 1611–29), commissioned the painter Sumiyoshi Jokei and his assistants to copy them. The last of the original scrolls were lost in fires in 1631 and 1661 and only the Sumiyoshi copies remain. (Plates 121, 122)

Nezame Monogatari Emaki
(*Tale of Nezame*)
1 scroll. Yamato Bunkakan, Nara. Heian period (12th century). National Treasure.

This *emaki* is based on the *Yowa no Nezame Monogatari,* which deals with a complicated love triangle. The original number of scrolls is not known, and the one extant scroll contains only four pictures and four textual portions. Errors in the text make it difficult to follow the story. The pictures are executed in the *tsukuri-e* technique and are among the most brightly decorative paintings using this device. (Plate 12)

Obusuma Saburō Ekotoba
(*Story of the Samurai Saburō*)
1 scroll. Asano Collection, Tokyo. Kamakura period (13th century). Important Cultural Property.

At one time a samurai, Yoshimi Jirō, and his younger brother, Obusuma Saburō, lived in Musashi Province. The elder brother married a court lady and lived a gracious, cultivated life, while the younger married the ugliest woman in eastern Japan and devoted himself to the military arts. After the death of his brother, Obusuma mistreated Yoshimi's family and stopped the lord of Musashi from marrying his late brother's beautiful daughter. This scroll is quite unusual because the life of a provincial samurai is seldom the subject for an *emaki*. (Plate 38)

Saigyō Monogatari Emaki
(*Biography of the Monk Saigyō*)
1 scroll. Tokugawa Reimeikai, Tokyo. 1 scroll. Ohara Collection, Okayama Prefecture. Kamakura period (13th century). Important Cultural Property.

This *emaki* depicts the deeds and experiences of the poet-monk Saigyō (1118–90). The Tokugawa Reimeikai scroll includes the following scenes: Satō Norikiyo (Saigyō's name before he entered the priesthood) arriving home determined to become a monk; Saigyō throwing his daughter from the veranda in order to overcome his attachment to his family; Saigyō telling his wife about his decision to become a monk; and Saigyō having his hair shaved off when he enters the priesthood in the backwoods of Saga Province. The Ohara scroll depicts the monk's poetic journeys: we see Saigyō composing a *waka* poem on New Year's Eve while taking lodging on a journey; Saigyō walking to Mount Yoshino to view cherry blossoms; and Saigyō traveling to Kumano. Especially in this second scroll, each section of text acts as a poetic introduction to the painting that follows. (Plates 28, 29–30)

Sanjūrokkasen Emaki
(*The Thirty-six Poetic Geniuses*)
Fragments. Various collections. Kamakura period (13th century). Important Cultural Property.

This *emaki* contains the portraits and poems of thirty-six leading poets such as Kakinomoto Hitomaro (seventh century) and Ki Tsurayuki (died 946), as well as short descriptions of their lives. The *emaki* originally comprised two scrolls that were owned by the Satake family, but both were later cut up into separate pieces. The fragments now belong to several collectors.

The historical poets are portrayed as vividly as if they were the artist's contemporaries. This work is attributed to Fujiwara Nobuzane (c. 1177–1265), a skillful portraitist in the *yamato-e* tradition. (Plate 31)

Shigi-san Engi
(*Legends of Shigi-san Temple*)
3 scrolls. Chōgosonshi-ji, Nara. Heian period (12th century). National Treasure.

117. Matsuhime Monogatari Emaki. *The story depicted in this* emaki *concerns the tragic marriage of the courtier Saemon and Matsuhime, the daughter of an assistant chief of the imperial guard. Saemon's parents strongly disapproved of the marriage because Matsuhime was neither rich nor well connected, and one day, while Saemon was out, they had their men kill the girl. Here, on an autumn evening, Saemon follows the ghost of his bride, for whom he has been searching, into a thatched hut, where it tells him the entire story. The oversized arrowroot that twists around the hut like a jungle vine dramatizes this emotional scene. Muromachi period, 16th century. Tōyō University, Tokyo.*

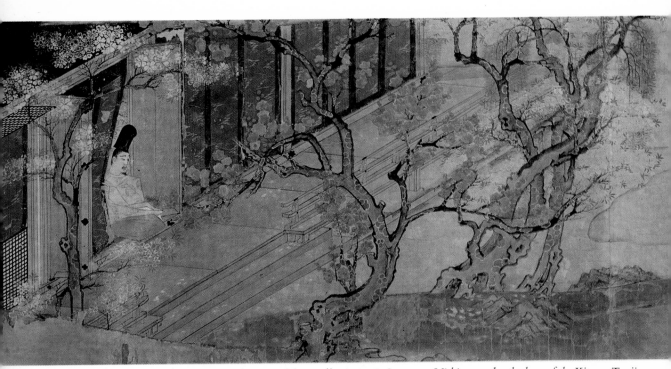

118. Matsuzaki Tenjin Engi. *The main character of this scroll painting is Sugawara Michizane, also the hero of the* Kitano Tenjin Engi. *He is seen gazing from the veranda of the Plum Palace at the blossoming plum tree in his garden, which he is seeing for the last time before he leaves for exile in Kyūshū. The tree is the focal point of the composition and is oversized to dramatize the sadness of the scene. The use of delicate and harmonious colors and precise drawing combine to create an extremely attractive* emaki. *Kamakura period, 14th century. Bōfu Temman-gū, Yamaguchi Prefecture.*

This *emaki* illustrates the miraculous deeds of Myō-ren, a Buddhist monk of the early tenth century who built a temple on Shigi-san, a mountain in Yamato Province, in which he enshrined an image of Bisha-mon-ten, the guardian deity of the north. It also tells of Myōren's meeting with his elder sister.

The first scroll is entitled "The Flying Granary." It shows how Myōren confines himself to Mount Shigi and does not descend from the place in order to beg for food. Instead, he bestows magic power on a golden begging bowl and makes it fly to a rich man's house in the village at the foot of the mountain. When the bowl is filled with food, it returns to the monk by air. One day the rich man's servants unintentionally neg-lect the bowl and leave it in a corner of the granary. The bowl slips out of the building and flies back to the mountain, carrying the entire granary with all its stored-up rice bales. Responding to the rich man's pleas, Myōren orders the bowl to carry the bales of rice back to the spot where the granary had stood, but he keeps the actual building on Mount Shigi.

In the second scroll, called "The Miraculous Cure of the Engi Era," Myōren is asked to pray for the re-covery of Emperor Daigo, who is very ill. Because of the monk's secret prayer of the "Protection of the Swords," a boy dressed in swords, who is the human manifestation of a Buddhist guardian spirit named Ken no Gohō, appears in front of the emperor. The emperor recovers instantly.

In the third scroll, entitled "The Nun," Myōren's elder sister, a nun, comes to Nara in search of her brother, who had left his home more than twenty years before. While she is spending some days in prayer at Tōdai-ji, the Buddha appears to her in a dream and instructs her to go to Mount Shigi. She finally reaches the spot, is reunited with her brother, and spends the rest of her days with him.

Each story in this *emaki* is independent of the others, yet all three combine to develop a unified narrative account. The work has been attributed to the monk Kakuyū (1053–1140), also called Toba Sōjō, but with-out sufficient supporting evidence. Because of the ex-tremely accurate rendering of the architecture of the imperial palace (Seiryō-den), some scholars attribute the *emaki* to a court painter who had a good knowl-edge of Buddhism; others feel it was created by a

Buddhist monk-painter who had a close relationship with the imperial court. (Plates 13, 14, 15, 16, 17, 18, 19)

Taima Mandara Engi
(Legends of the Taima Mandala)
2 scrolls. Kōmyō-ji, Kanagawa Prefecture. Kamakura period (13th century). National Treasure.

This *emaki* depicts the legendary account of the origin of the *mandala* bequeathed to the Taima tem-ple in the province of Yamato. According to tradition, a princess, the daughter of a court dignitary of the Nara period, became a fervent believer in Amida Bud-dha while still a young girl. She confined herself to the Taima temple and prayed that she might see a vision of the living Amida. A nun, an incarnation of Amida, appeared to her on the seventh day of her con-finement and told her to gather one hundred horse-loads of lotus stems if she wanted to see Amida. The princess sought the help of the imperial court and the stems were sent from Omi Province. After the nun had spun thread out of the lotus stems, she had her attendant, an incarnation of Kannon, weave scenes of Amida's Western Paradise. The nun told the girl the significance of the *mandala* pictures and revealed her-self as Amida, then left for the Western Paradise. More than a decade later, the princess died and was reborn in the paradise of which she had always dreamed. (Plates 54, 59)

Tengu Zōshi
(Stories of Conceited Priests)
2 scrolls. Tokyo National Museum, Tokyo. Kama-kura period (13th century). Important Cultural Prop-erty.

This *emaki* cynically portrays the priests of the tem-ples of Nara and Kyoto as *tengu*, or long-nosed gob-lins, the symbol of the braggart. Besides the Enryaku-ji scrolls, which are presently housed in the Tokyo National Museum, scrolls from the Onjō-ji and Mii-dera and copies of the Kōfuku-ji and Tōdai-ji scrolls are also preserved. Despite their ostensibly religious focus, these scroll paintings differ in content from and lack the depth of the illustrated sutra *emaki*, the legend-

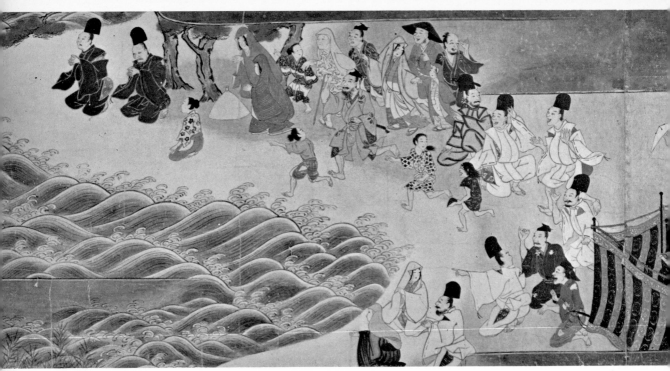

119. Kuwanomi-dera Engi *(Legends of Kuwanomi-dera). Muromachi period, 16th century. Kuwanomi-dera, Shiga Prefecture.*

120. Seiryō-ji Engi *(Legends of Seiryō-ji). Muromachi period, 16th century. Seiryō-ji, Kyoto.*

ary accounts of the origins of temples and shrines, and the pictorial biographies of learned priests. (Plate 50)

Tōhoku-in Shokunin Uta-awase Emaki
(Tōhoku-in Poetry Contest Among Members of Various Professions)
1 scroll. Tokyo National Museum, Tokyo. Kamakura period (14th century). Important Cultural Property.

This *emaki* was created to commemorate the *waka* poetry contest that was supposedly held in the fall of 1215 by tradesmen who had gathered for a prayer meeting at the Tōhoku-in; the theme of the contest was "the moon and love." Men and women of various trades, clad in distinguishing costumes, are portrayed: a doctor, a smith, a swordmaker, a sorceress, and a woman pearl diver on the left-hand side; a fortuneteller, a carpenter, a caster, a gambler, and a merchant on the right. A restorer acts as judge. The pictures are accompanied by *waka* poems. This work is similar in style to other poem scrolls, but it contains a more demotic element. (Plate 69)

Tori Uta-awase Emaki
(Poetry Contest of the Birds)
1 scroll. Keiō University, Tokyo. Muromachi period (16th century).

This *emaki* is also called *Suzume no Hosshin* (The Sparrows Entering the Priesthood). According to the story, a baby sparrow was eaten by a snake, and many sympathetic birds composed *waka* poems to help console the parent sparrows. The parents, too, wrote poems in reply, and shortly afterward entered the priesthood. The two sparrows visited temples throughout the country and eventually died, to be reborn in paradise. (Plate 92)

Tōsei Eden
(The Eastern Journeys of Ganjin)
5 scrolls. Tōshōdai-ji, Nara. Kamakura period (13th century). Important Cultural Property.

This scroll painting illustrates the life of the priest Ganjin (in Chinese, Chien-chen), who came to Japan from China in 754 to propagate the Risshū (Disci-

pline) sect of Buddhism. The story begins with Ganjin entering the priesthood at the age of fourteen. Later, encouraged by Eiei and Fushō, Japanese monks who had come to China, Ganjin attempted to sail to Japan. He was delayed several times by storms, pirates, and other adversities, but was finally successful in his fifth attempt to cross the sea. The account ends with his death at the Tōshōdai-ji, which he established in Nara.

As a result of the artist's attempt to portray Chinese landscapes and Chinese customs, the style of this *emaki* is different from that of an ordinary *yamato-e* work. The inscription at the end informs us that the name of the artist was Rokurōbei Rengyō and that the *emaki* was given to the Tōshōdai-ji in 1298 by Ninshō (1217–1303), chief priest of the Gokuraku-ji, a branch temple of Tōshōdai-ji located in Kamakura. (Plate 42)

Yamai no Sōshi
(Scroll of Diseases and Deformities)
10 sheets. Sekido Collection, Aichi Prefecture. Kamakura period (12th century). National Treasure.

This *emaki* depicts various human diseases. Originally, it was one scroll with fifteen sections of text and the same number of illustrations, but it has been cut up and is now owned by different collectors. The Sekido Collection includes illustrations of nine diseases: a man suffering from an eye disease (the accompanying script is on a separate sheet), a man with loose teeth, a man with an anal fistula, a man with crab lice, a woman suffering from sunstroke, a woman with bad breath, a man with a cold, a man with a lisp, and a hermaphrodite.

This *emaki* is often associated with the *Jigoku Zōshi* and *Gaki Zōshi* scrolls because of the idea that the suffering man experiences in the form of disease is a result of the cycle of spiritual cause and effect and parallels the pain experienced in the realms of the hungry ghosts and of hell. This work is also stylistically similar to the *Hell* and *Hungry Ghost* scroll paintings. (Plates 26, 27)

Yata Jizō Engi
(Legends of Jizō)
2 scrolls. Yata-dera, Kyoto. Kamakura period (14th century). Important Cultural Property.

121. Nenjū Gyōji Emaki.
*Edo period, 17th century
(copy). Tanaka Collection,
Tokyo.*

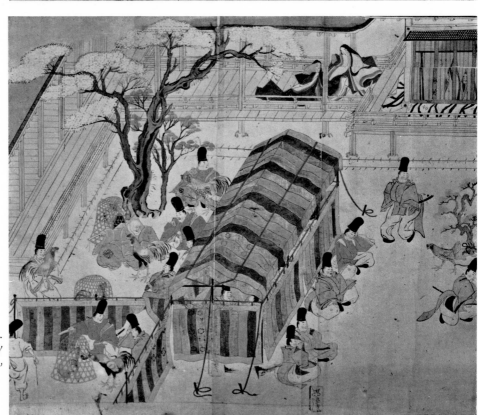

122. Nenjū Gyōji Emaki.
*Edo period, 17th century
(copy). Tanaka Collection,
Tokyo.*

This *emaki* deals with the legendary origin of the Yata-dera and the miraculous virtues of its principal deity, the Bodhisattva of women and children, travelers, and souls suffering in hell—Jizō. The work depicts the story of a high priest named Mammei who traveled through hell guided by King Yama, the ruler of the world of the dead. While in hell, Mammei met Jizō in human form and received various messages from this benevolent deity. When he returned to this world, he carved an image of Jizō and founded the Yata-dera. (Plate 94)

Zuijin Teiki Emaki
(The Imperial Guard Cavalry)
1 scroll. Okura Cultural Foundation, Tokyo. Kamakura period (13th century). National Treasure.

Zuijin were military officers of the imperial guard whose duty was to escort ex-emperors and nobles on various occasions. This *emaki* portrays three military officers of the Nimpyō (1151–54) and Eiryaku (1160–61) eras at the end of the Heian period and six officers and eight horsemen attached to ex-Emperor Gosaga in the Kamakura period. The pictures are executed in black ink with faint colors added to the faces and to the trappings of the horses. An inscription reads: "Military officers of the ex-Emperor, October 1247." The date very likely refers to the date of execution of the work. (Plates 47, 95)

Glossary

Amida Buddha (Sanskrit Amitābha): "Lord of Boundless Light"; the most widely venerated of the transhistorical Buddhas, who presides over the Western Paradise where he receives the faithful after death

ashide-e: "reed-hand painting"; technique by which loose, flowing calligraphy from a poem is used to form part of a pictorial image

Bodhisattva: an inherently enlightened being within the hierarchy of Buddhism who postpones his own complete emancipation from the world until he can save all sentient beings

Buddha: fully awakened or enlightened being. "The" Buddha refers to the Indian sage Siddhārtha Gautama (c. 563–483 B.C.), born the son of the ruler of the Sākya kingdom and also known as Sākya-muni—"the sage of the Sākya clan." According to tradition, Gautama forsook the luxury of his princely existence to seek after Truth. He experienced perfect enlightenment after seven years of religious practices and taught for forty-five years more. As Buddhism developed, it came to include various other "transhistorical" Buddhas, such as Amida, who have no historical basis.

Buddhism: religion inspired by Gautama Buddha, which teaches release from the painful cycle of birth and death through elimination of desire and subsequent enlightenment

eden: pictorial biographies of important historical personages, usually priests

edokoro: official bureau of painting set up by the imperial court and later, the shoguns; also, a temple bureau of painting

ekotoba: "picture and word"; usually refers to scroll paintings in which text and illustration alternate

emaki: illustrated horizontal handscroll, usually of narrative content. Extant *emaki* in Japan date primarily from the twelfth century onward.

emakimono: see *emaki*

engi: in Buddhist doctrine, "dependent origination," a reference to the doctrine that everything results from determinable causes and circumstances, according to the doctrine of karma or "cause and effect." In *emaki,* it refers to the usually legendary origin of a shrine or temple.

fukinuki-yatai: "blown-away roofs"; a device by which roofs and ceilings of houses and rooms are arbitrarily removed in order to show interior scenes directly; probably developed in Japanese art in the mid-eleventh century

gaki: ghosts who are doomed to hunger and thirst

that can never be satisfied because they were avaricious as human beings or because their descendants have not provided them with proper nourishment and care at the household altars

genre painting: painting of scenes of daily life and various customs

hakubyō: "white pictures"; works created in black monochrome ink

hampuku-byōsha: "repetition picture"; technique by which a character is shown again and again in front of a changing background

hikime-kagihana: "slit eyes and hooked noses"; convention used to portray the faces of aristocrats using simple horizontal strokes for eyes and stylized hooks for noses

iji-dōzu: "different time, same illustration"; device used to show multiple actions of a figure in front of a static background

kakemono: vertical, hanging scroll

kana: phonetic syllabary derived from Chinese characters that enabled the Japanese to write their own native language; developed from the ninth century onward

kara-e: "Chinese painting"; Chinese-style painting, often done in monochrome ink, dealing with Chinese themes

kasen: "sages of poetry"; celebrated traditional poets who were honored in *emaki* with portraits and samples of their poems

machi-eshi: "town painters"; painters accessible to the general public and not limited to the service of courts or temples

mandala (Sanskrit *maṇḍala*): a diagrammatic representation of the relationships among divinities, usually Buddhist but also Shintō; a *mandala* may also depict the abode of such deities both in paradise and in sanctuaries on earth

mono no aware: an aesthetic perception and feeling induced by the association of beauty and sorrow

monogatari: a narrative account, such as a novel, story, or history in literary form

nikki: diary

nise-e: "likeness pictures"; type of realistic portraiture developed in Japan from the mid-twelfth century onward

onna-e: "women's pictures"; term used to designate illustrations of such works of court inspiration as romances and diaries; usually show quiet, static, indoor scenes; characterized by the use of the *hikime-kagihana* technique *(see)*

otogi zōshi: short folk tales, sometimes similar to fairy stories, often containing moral precepts; especially popular during the Muromachi period

otoko-e: "men's pictures"; quick, lively sketches full of action and vigor; usually refers to illustrations of fast-moving narratives

Pure Land Buddhism: a popular movement of Buddhism from the late Heian and Kamakura periods on that preached salvation for the faithful in the Western Paradise (Jōdo) of the transhistorical Amida Buddha

roku-dō: the six realms of rebirth—that of heavenly beings *(ten),* human beings *(jin),* angry demons *(ashura),* beasts *(chikushō),* hungry ghosts *(gaki),* and hell *(jigoku).* According to Buddhist doctrine, a living being is doomed to the wheel of birth and death and to rebirth in one of the six realms until he achieves enlightenment and release from the bondage of life.

sarugaku: "monkey music"; humorous and often vulgar dance and song arrangements accompanied by drums and flute, popular during the late Heian and early Kamakura periods

shasenbyō: "oblique line depictions"; pictures, usually of courtly inspiration, characterized by parallel slanting lines to depict architectural elements

shikishi: sheets of paper backed with cardboard, usually about twenty-five centimeters square, used for writing poems or for painting

Shingon: one of the esoteric sects of Buddhism characterized by mystic ritualism and complicated speculative doctrines

Shintō: indigenous animistic religion of Japan; emphasis upon the worship of nature and of ancestors

shogun: military dictator and chief of government under Japan's feudal system (from Kamakura through Edo periods)

sōshi (*zōshi* in compounds): album or sketch of usually short accounts connected to one another by a common theme

sutra: sacred Buddhist scripture

Tendai: an eclectic sect of Buddhism, characterized by esoterism and speculative doctrines

tsukuri-e: "made-up picture"; technique typical of some *yamato-e emaki* in which heavy, opaque pigments are carefully and systematically applied or built up over a white lead pigment base. The original ink outlines, concealed by paint, are repainted over the colors.

ukiyo-e: "pictures of the floating word"; type of art (especially known to the West through its woodblock prints), popular in the Edo period, depicting the amusements and pleasures of the nonaristocratic classes

uta-awase: poetry contest in which two sides submit poems to be judged; competitions of this sort were sometimes the subject of *emaki* art

waka: thirty-one-syllable poem of great lyric content; also called *tanka*

yamato-e: Japanese-style painting, often done in color, depicting Japanese scenes and concerns

zōshi: see *sōshi*

Bibliography

General

Conze, Edward: *Buddhism: Its Essence and Development*. New York: Harper and Row, 1959.

de Bary, Wm. Theodore (ed.): *Sources of the Japanese Tradition*. New York: Columbia University Press, 1958.

Morris, Ivan: *The World of the Shining Prince: Court Life in Ancient Japan*. New York: Knopf, 1964.

Sansom, G. B.: *A History of Japan,* 3 vols. London: Cresset Press, 1958–63.

————: *Japan: A Short Cultural History:* rev. ed. New York: Appleton-Century-Crofts, 1943.

Varley, H. Paul: *The Onin War*. New York: Columbia University Press, 1967.

Literature

Harris, H. Jay: *The Tales of Ise*. Tokyo: Tuttle, 1972.

McCullough, Helen Craig: *The Taiheiki: A Chronicle of Medieval Japan*. New York: Columbia University Press, 1959.

————: *Tales of Ise: Lyrical Episodes from Tenth-century Japan*. Stanford, Calif.: Stanford University Press, 1968.

Morris, Ivan: *The Pillow Book of Sei Shōnagon,* 2 vols. New York: Columbia University Press, 1967.

Waley, Arthur: *The Tale of Genji*. New York: Random House/The Modern Library, 1960.

Emaki

Akiyama, Terukazu: *Japanese Painting*. Switzerland: Skira, 1961.

Fontein, Jan: "Kibi's Adventures in China: Facts, Fiction, and Their Meaning." *Boston Museum Bulletin,* No. 344, 1968.

Morris, Ivan: *The Tale of Genji Scroll*. Tokyo: Kodansha International, 1971.

Okudaira, Hideo: *Emaki: Japanese Picture Scrolls*. Tokyo: Tuttle, 1962.

Paine, Robert T.: "The Scroll of Kibi's Adventures in China: A Japanese Painting of the Late Twelfth Century, Attributed to Mitsunaga." *Boston Museum Bulletin,* No. 183, 1933.

————: *Ten Japanese Paintings in the Museum of Fine Arts, Boston*. New York: Japan Society, 1939.

Seckel, Dietrich: *Emakimono*. New York: Pantheon, 1959.

Soper, Alexander C.: "The Illustrated Method of the Tokugawa Genji Pictures." *Art Bulletin,* Vol. 37, No. 1, 1955.

———: "The Rise of Yamato-e." *Art Bulletin,* Vol. 24, No. 4, 1942.

Tanaka, Ichimatsu (ed.): *Nihon Emakimono Zenshū,* 24 vols. Tokyo: Kadokawa Shoten, 1958–69. Contents: *Genji Monogatari Emaki* (ed. Mori); *Shigi-san Engi* (ed. Okudaira); *Chōjū Giga* (ed. Miya); *Ban Dainagon Ekotoba* (ed. Tanaka); *Kokawa-dera Engi E, Kibi Daijin Nittō E* (ed. Umezu); *Jigoku Zōshi, Gaki Zōshi, Yamai Zōshi* (ed. Ienaga); *Kegon Engi* (ed. Kameda); *Kitano Tenjin Engi* (ed. Minamoto); *Heiji Monogatari Emaki, Mōko Shūrai Ekotoba* (ed. Miya); *Ippen Hijiri E* (ed. Miya); *Saigyō Monogatari Emaki, Taima Mandara Engi* (ed. Shirahata); *Murasaki Shikibu Nikki Emaki, Makura no Sōshi Emaki* (ed. Mori); *Hōnen Shōnin Eden* (ed. Tsukamoto); *Genjō Sanzō E [Hossō-shū Hiji Ekotoba]* (ed. Minamoto); *Kasuga Gongen Reigen Ki E* (ed. Noma); *E Inga-kyō* (ed. Kameda); *Nezame Monogatari Emaki, Komakurabe Gyōkō Emaki, Ono no Yukimi Gokō Emaki, Ise Monogatari Emaki, Nayotake Monogatari Emaki, Hazuki Monogatari Emaki, Toyo no Akari Ezōshi* (ed. Shirahata); *Obusuma Saburō Emaki, Haseo Zōshi, Eshi no Sōshi, Jūnirui Kassen Emaki, Fukutomi Zōshi, Dōjō-ji Engi Emaki* (ed. Umezu); *Sanjūrokkasen E* (ed. Mori); *Zenshin Shōnin E, Boki E* (ed. Miyazaki); *Tōsei Den Emaki* (ed. Kameda); *Ishiyama-dera Engi E* (ed. Umezu); *Yugyō Shōnin Engi E* (ed. Miya); *Nenjū Gyōji Emaki* (ed. Fukuyama).

Toda, Kenji: *Japanese Scroll Painting.* Chicago, University of Chicago Press, 1935.

Tomita, Kōjiro: "The Burning of the Sanjō Palace: A Japanese Scroll Painting of the Thirteenth Century." *Boston Museum Bulletin,* No. 139, 1925.

Yashiro, Yukio: "Scroll Paintings of the Far East." *Transactions and Proceedings of the Japan Society,* Vol. 33, 1935.

Index

The Arts of Japan Series

These books, which are a selection from the series on the arts of Japan published in Japanese by the Shibundō Publishing Company of Tokyo, will in future volumes deal with such topics as haniwa, ink painting, architecture, furniture, lacquer, ceramics, textiles, masks, Buddhist painting, portrait painting and sculpture, and early Western-style prints.

Published:

1 Design Motifs
2 Kyoto Ceramics
3 Tea Ceremony Utensils
4 The Arts of Shinto
5 Narrative Picture Scrolls
6 Meiji Western Painting

In preparation:

Haniwa
Ink Painting
Shoin Architecture

The "weathermark" identifies this English-language edition as having been planned, designed, and produced at the Tokyo offices of John Weatherhill, Inc., in collaboration with Shibundō Publishing Company. Book design and typography by Dana Levy. Text composed by Kenkyūsha. Engraving by Hanshichi. Printing by Nissha and Hanshichi. Bound at Oguchi Binderies. The type of the main text is set in 11-pt. Bembo with hand-set Goudy Bold for display.